OIL PAINTING
with the MASTERS

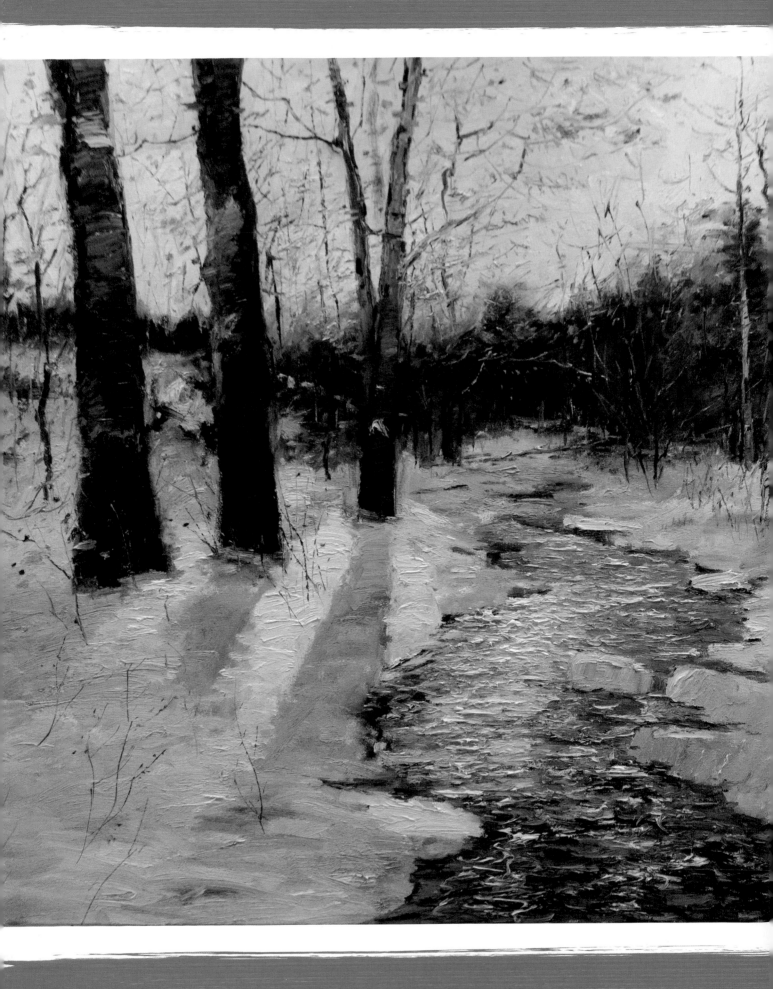

OIL PAINTING
with the MASTERS

Essential Techniques from Today's Top Artists

CINDY SALASKI

NORTH LIGHT BOOKS
Cincinnati, OH
www.northlightshop.com

Phillips Mill Stream in Winter
George Gallo
Oil on canvas, 48" × 60" (122cm × 152cm)

CONTENTS

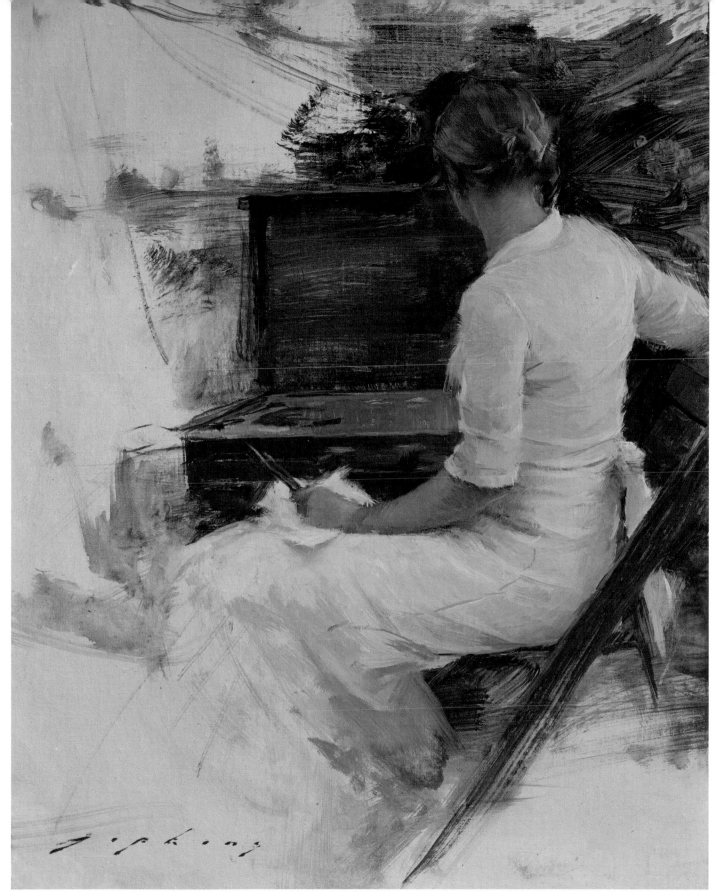

Katie Painting
Jeremy Lipking
Oil on linen, 14" × 11" (36cm × 28cm)

For additional demos, bios, art and more, visit **artistsnetwork.com/oil-painting-with-the-masters**.

5

INTRODUCTION

While reading one of my favorite art books, *Watercolour Impressions* by Ron Ranson, I thought to myself, *This is such a wonderful book. Why hasn't someone written one like it featuring the great master oil painters of today?* As I continued to turn the pages, admiring one beautiful impressionistic watercolor painting after another, the thought struck me, *Why don't I write it?*

Like Ranson, I became interested in painting late in life. I became consumed by the beautiful work of the contemporary Impressionists. Great painters like Albert Handell, Kevin Macpherson and Jeremy Lipking fascinated me. I began to search for more oil painters who had this gift, this magic touch. I sought out the great master oil painters of today and I found them.

If you're like me, you aspire to paint like a master. You stand in front of a painting in a museum and say to yourself, *If only I could paint like that.* You watch a master like Camille Przewodek paint during a workshop and you think, *That looks easy. I think I can paint like her.* So you try to paint like Przewodek, but you discover that it's not as easy as it looks.

You try to do another painting. Once again, it's not as good as Przewodek's. You might think, *I just don't have any talent. I haven't been blessed with the magic touch.* Thinking like that is a big mistake. Each one of us possesses that natural gift we assume belongs only to the chosen few.

A strong passion for painting and years of hard work are what made the painters in this book the great masters they are today. Unleash your talent by learning everything you can about composition, values, color, texture and edges, and doing hundreds of paintings following the methods of the masters.

I worked at drawing on and off for years. Copying cartoons from the newspaper or comic books was easy for me. My copies looked exactly like the originals. Yet whenever I tried to draw a portrait of a person, it looked like something a child drew.

Then one day I discovered the book *How to Draw Lifelike Portraits from Photographs* by Lee Hammond. That discovery led to a big turning point for me. After studying Hammond's book and learning how to use pencil shading and blending, I began drawing portraits that looked like real people.

I'll never forget the day I showed one of my brothers a portrait I did of Pierce Brosnan. He just stared at it and said, "You did this?" And when I showed it to a cousin, she said, "Wow! Cindy, you should be an artist!" My confidence grew by leaps and bounds thanks to that book. I became a bit arrogant after that, though, figuring that if drawing was that easy, then painting should be a cinch.

It's been five years since I began painting in oils, and I still haven't reached that "Wow" moment yet. Yes, oil painting has humbled me. But I don't blame my failure on a lack of talent. I blame myself for not scheduling the time to paint every day.

If you're like me, and you haven't reached that "Wow" moment yet, then I encourage you to keep working hard until you do. Once you reach it, the feeling you experience will be one of the most joyous of your life. I know. I've experienced that feeling, that strong sense of achievement, with my drawings and I can't tell you how I yearn to experience it with my paintings.

If you don't aspire to paint like a master but just want to have fun painting, then I'm sure you'll also enjoy this book. After all, if you want to learn how to do anything and do it well, it's always wise to seek out the best teachers in any given field.

It is my pleasure to present to you twenty of the greatest master oil painters of today. I hope you enjoy the journey you take with them and achieve whatever goals you desire. Keep in mind that persistence and determination are the keys to success. So work hard. Feed your passion. And you, too, can become a master.

C. Salaski

Cindy Salaski

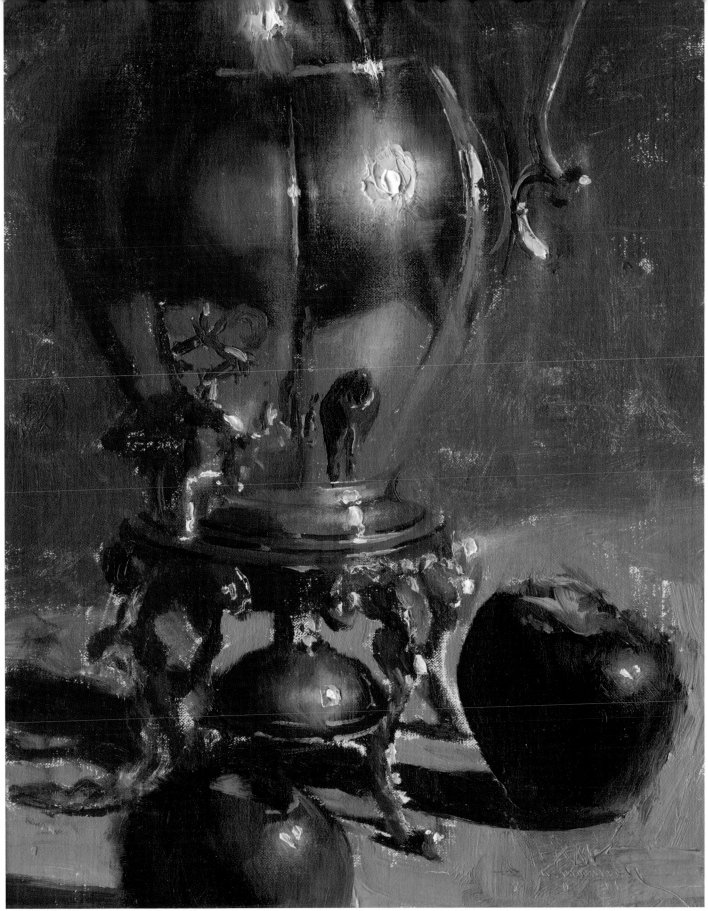

Silver Coffee Urn
C.W. Mundy
Oil on linen, 12" × 9" (30cm × 23cm)

MOOD & ATMOSPHERE
with Marc R. Hanson

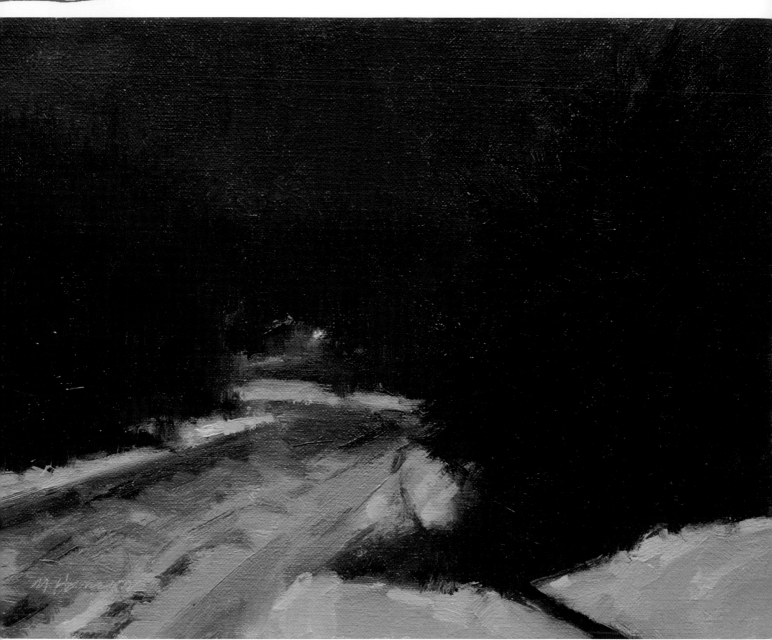

January Moonlight
Marc R. Hanson
Oil on linen, 9" × 12" (23cm × 30cm)

" **WHEN I JUDGE ART,** *I take my painting and put it next to a God-made object like a tree or flower. If it clashes, it is not art.*"

— PAUL CÉZANNE

ABOUT **MARC R. HANSON**

Marc R. Hanson doesn't have to be inspired to paint. "Being alive and living with art in my life is enough to keep me painting for the rest of my life. I am constantly curious and interested in exploring the visual qualities of many things, but Mother Nature is my muse. The constantly changing landscape and mood of the natural world is what makes my artistic blood flow."

As a child, Marc enjoyed drawing birds. He was fascinated by them and felt he wanted to spend his life studying them. During college he majored in biology with the goal of becoming an ornithologist. He soon realized his interest in birds was more aesthetic than scientific, so he transferred to the Art Center College of Design in Pasadena, California, where he majored in illustration.

Marc's art mentor was his father. "Dad was an artist, and although he had a career as an Air Force officer, he spent nearly all of his spare time painting and drawing. I grew up with an art supply store in the house. Crow quill pens and India ink, oil and watercolor paints, pastels and lots of kneaded erasers—they were always there and available for my brother and me to use."

After college and a brief stint as a staff illustrator in Sacramento, California, Marc moved to Minnesota where he lived for thirty-three years while raising a family and pursuing his art. He relocated to Colorado in the fall of 2012.

"I have pursued a career as a painter for many years now. Along the way my methods, materials and focus have evolved. As a naturalist at heart, the landscape is the perfect vehicle for expressing the joy I have for the world that surrounds me. My real interest and challenge as a painter is how to best manipulate the core principles of painting into effective visual statements. I'm most successful when I'm able to communicate that joy to the viewers of my paintings."

Marc teaches landscape painting workshops in many locations nationally. "I love working with other painters in their pursuit to better their craft. My goal is not to have them assimilate my style and technique, but to teach them how to more closely examine the subject and apply the principles that representational painters must follow to become effective visual communicators."

A Signature Member of the Oil Painters of America (OPA), Marc has shown his work in galleries and museums nationally and internationally since the early 1980s. Among his many awards, he's placed four times in *Pastel Journal's*

Marc R. Hanson

Pastel 100 Competition. Marc has also won the Award of Excellence at the OPA National Exhibit in 2000, 2007, 2009, 2010 and 2011.

His work has also received the following awards: finalist in *International Artist Magazine's* Art Prize Challenge, 3rd Place Landscape in Pastel 100 (2008), the Pastel Award at the Society of Master Impressionist Show at the Sunset Art Gallery in Amarillo, Texas, and the Award for Excellence, Landscape at the Oil Painters of America's National Exhibit at the Legacy Gallery in Scottsdale, Arizona.

In 2011 his painting *Right or Left* was awarded the Bronze Medal for Painting at the OPA National Exhibition in Coeur d'Alene, Idaho, and was featured on the cover of the November 2012 issue of *Southwest Art Magazine*.

Marc has also been featured in *American Art Collector* magazine, *The Artist's Magazine*, *Plein Air Magazine* and *Pastel Journal* magazine.

For additional demos, bios, art and more, visit **artistsnetwork.com/oil-painting-with-the-masters**.

9

ON **MOOD & ATMOSPHERE**

These are several ways to control and/or improve the way you paint mood and atmosphere in your paintings.

- Read about recessive color theory.
- Experiment with trying to make your color mixtures recede and reflect the atmosphere that you are painting.
- Paint outdoors. Get out into the field to observe atmospheric situations from life—this is the best way to learn to paint atmosphere, and how to portray the mood of a landscape.

Unless you want to paint a generic reflection of the landscape, take your painting gear into the field and "paint to understand" the truth in nature. Making observational studies creates a huge well of information that you will retain, and have as a visual library. When you're back in the studio creating a particular mood or situation, trying to realize a concept that you have thought of and decided that you'd like to paint, all of the previous experience of painting from life will prove invaluable.

Say you're interested in painting the calm drama immediately following a strong evening thunderstorm—the quality of the light that bathes the landscape right after the violence of the storm has passed. Or the way the sun pokes through the steel gray clouds, pouring a warm yellow-orange light on all the greens in the landscape. You want to capture all of that along with the feeling of relief that the storm is over. How do you achieve this goal? You must get out there and paint it to understand it, and thus, be able to translate it.

Concept, color, value and the quality of the edges are the most important controlling factors in painting the idea of mood or atmosphere in your paintings. Make small studies from life. These situations move fast. Don't try to paint large paintings when making observational mood and atmospheric studies. Try to capture major shapes and the color harmony of your overall impression. Observe and note the way the edges of forms and layers of the landscape interact with each other.

If the mood you have decided that you want to portray is about the fear and apprehension that Mother Nature is capable of instilling in us, then the color, brushwork, edge control and value structure of your painting will determine how successfully you recreate that mood, and how the viewer responds when they see your painting.

To effectively create mood and atmosphere in your paintings, you must first understand what it is you are trying to portray. Most important to that understanding is having a good solid concept.

Concept is the reason that you're painting the painting. It is the idea that you wish to convey to the viewer, and it is the guide to everything that you will do in your painting—from the selection of the surface you paint on, to the approach used to paint, the color scheme, the values, the edges and all other considerations.

En Plein Air

Marc's most memorable plein air experience was painting in Cape Town, South Africa. "I was painting in a remote place that always held such great mystery for me. The scale and exotic quality of the land there captured me and presented a subject unlike anything I had ever seen before. I only painted about six paintings while there, but every single one had an energy and inspired effort that I will never forget."

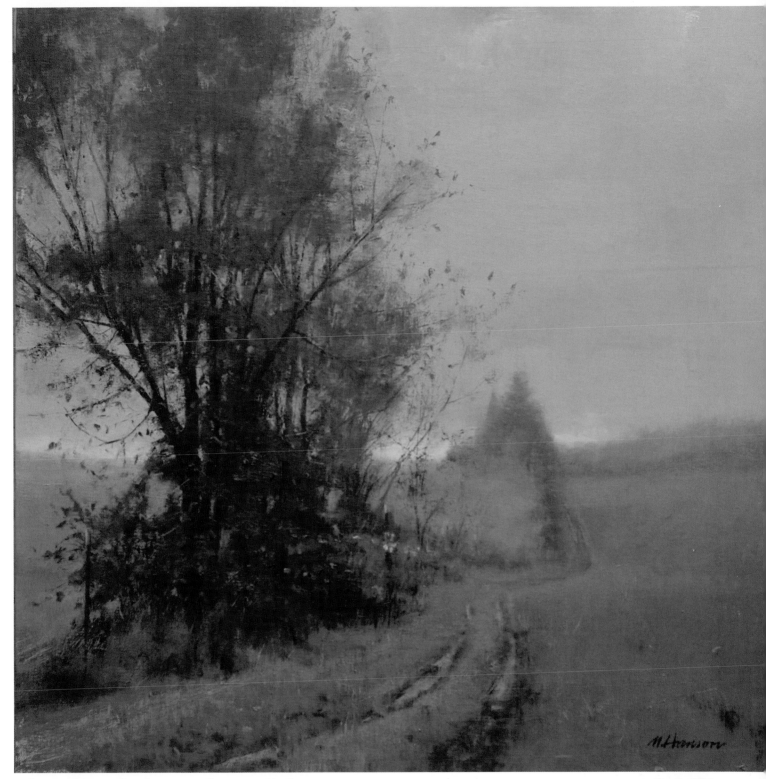

Values, Edges and Color Contribute to Mood
Marc was able to achieve the somber mood of a landscape
shrouded in mist by keeping the values close, the edges soft and
the color muted.

Oregon Mist
Marc R. Hanson
Oil on linen, 16" × 16" (41cm × 41cm)

For additional demos, bios, art and more, visit artistsnetwork.com/oil-painting-with-the-masters.

11

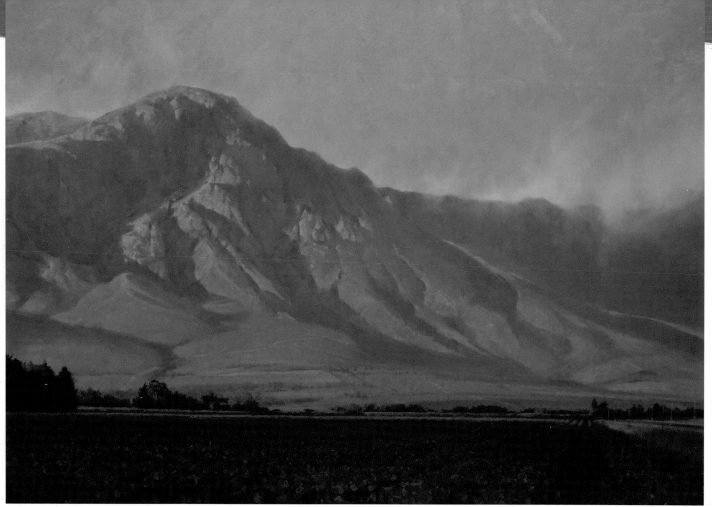

Light, Shadow and Horizon Lines Affect Atmosphere

Marc wanted to portray the beauty of the fading light in this valley at the end of the day. By using a low horizon that is in shadow, having lost the light of the day, and casting the warm light on the foothills, the atmosphere was set.

Hex River Valley
Marc R. Hanson
Oil on linen,
30" × 40" (76cm × 102cm)

Receding Color Intensity and Soft Edges Help Create a Foggy Mood

The title of this painting conveys the mood Marc wanted to paint. By using quickly receding color intensity from foreground to distance and painting the trees and foliage as silhouettes with softer edges as they recede, he was able to portray the mood of the very foggy hillside.

Foggy Top
Marc R. Hanson
Oil on linen, 30" × 36" (76cm × 91cm)

Cold Shadows Contrast with Warm Light
This painting is about the warming morning light as the sun rises and begins to light selected parts of the scene. Marc's goal was to paint the chill of the shadow in contrast to the warm orange-red light at the intersection in the road. The contrast between the cool gray shadows and the warmly lit areas helps to achieve that.

Right or Left
Marc R. Hanson
Oil on linen, 24" × 30" (61cm × 76cm)

For additional demos, bios, art and more, visit artistsnetwork.com/oil-painting-with-the-masters.

13

Capture Mood & Atmosphere
IN A LANDSCAPE PAINTING

There are two ideal times of day to capture dramatic light effects in paintings: before the sun rises, and after the sun sets.

In the painting for this demonstration, Marc decided to portray a chilled winter morning, just prior to sunrise. He wanted the viewer to feel the cold, to decide that they'd just as soon stay in bed on a morning like this and not have to go out into the frigid air. To accomplish that, he chose a reference photo that had many of those elements in it already and a color palette that was 98 percent cool. Even the warmer local colors of the grass and other objects were mixed to convey the feeling they are within the shadow of a pre-sunrise winter morning.

Follow the steps to capture mood and atmosphere in a landscape painting.

Materials

SURFACE

oil-primed linen board

BRUSHES

½" (13mm), ¾" (19mm) and nos. 6, 8, and 10 synthetic flats

no. 8 or 10 hog bristle flat

½" (13mm) and no. 4 synthetic brights

no. 2 nylon round

no. 4 sable round

no. 2 hog bristle filbert

2" (51mm) Chinese bristle varnish brush

PIGMENTS

Alizarin Crimson, Cadmium Lemon Yellow, Cadmium Red Light, Cadmium Scarlet, Cadmium Yellow Deep, Cobalt Blue, Permanent Rose, Titanium White, Transparent Oxide Red, Ultramarine Blue Deep, Venetian Red, Violet, Viridian, Yellow Ochre Light

OTHER

Liquin

odorless mineral spirits

palette knife

paper towel or rag

Reference Photo

Conceptual Sketch

When compared to the final painting, you'll notice that Marc eliminated the telephone poles leading into the middle ground. As the painting developed he realized there was going to be so much activity in the middle ground that the addition of the telephone poles would block the way into that area and would be distracting to what he wanted to portray.

Marc doesn't always make a conceptual sketch that is this detailed, but it's usually a good idea to do so. He recommends keeping them in a sketchbook so you can refer to them later. They are likely to stir up more ideas for you in the future.

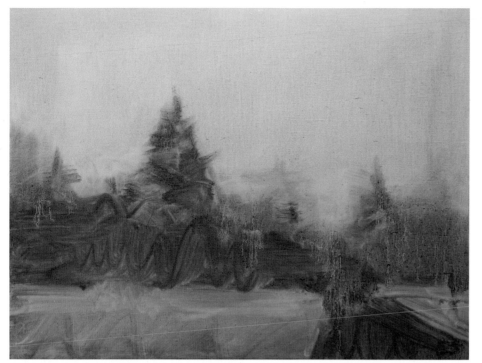

1 WASH BLOCK IN

Use a 2"(51mm) Chinese bristle varnish brush to lay down a wash. Mix Ultramarine Blue with a lot of odorless mineral spirits (OMS) to the consistency of watercolor. Beginning with the sky, lay color from the top down. As the color flows towards the horizon, mix in a bit of Yellow Ochre and Cadmium Lemon Yellow. Finish the wash with a touch of Permanent Rose. Mix it so the value is dark enough to make a statement, but doesn't overpower the scene.

Mix Ultramarine Blue with a little Alizarin Crimson, Cadmium Red Light and OMS to a value and color that represents the darker middle ground mass of the trees and buildings to come. Paint in the shape of the road with the same mixture. Paint the foreground shape of the field and snow with a mix of Ultramarine Blue and some of the gray from the middle ground mixture to keep it darker in value than the sky, but lighter in value than the tree mass. To simplify the composition, keep the number of shapes and the values of those shapes to around three or four.

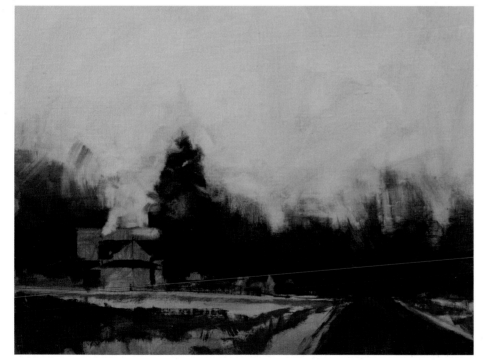

2 LAY IN THE DARKEST VALUES

Once your surface is dry, paint the large mass of trees using a no. 10 synthetic flat. Use Ultramarine Blue with a variation from cooler on the right to warmer on the left—the direction that the sunlight is coming from. For the cooler dark mixture on the right, try mixing some Alizarin Crimson and Viridian with the blue, tempered by a bit of Transparent Oxide Red. On the left side, the warmer side, mix Cadmium Red Light and a touch of Yellow Ochre into the blue as you warm the mixture up.

For the road, create a slightly warmer mixture—some Venetian Red with the blue. For the grasses, use Venetian Red and Yellow Ochre, as well as some Alizarin Crimson. Around the top of the tree line, refine the shapes with a clean rag or paper towel and a little OMS. Pick out negative shapes and begin controlling their edge quality, making them either soft or hard.

For additional demos, bios, art and more, visit **artistsnetwork.com/oil-painting-with-the-masters**.

15

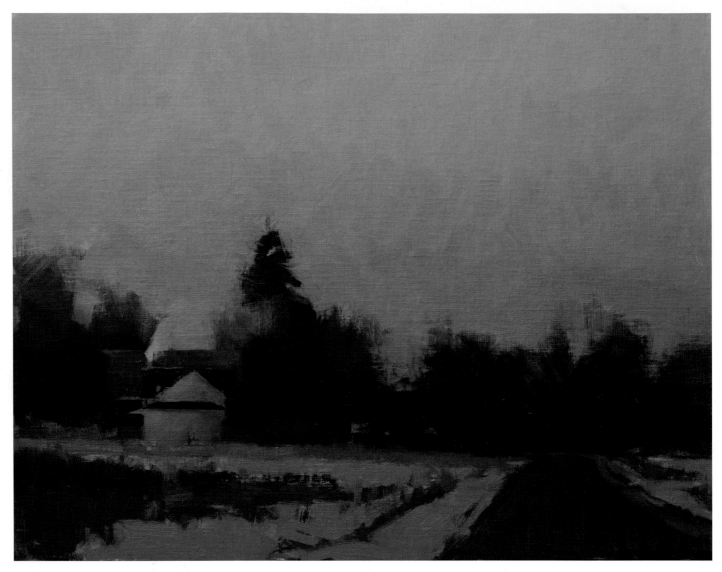

3 PAINT THE FIRST LAYER INTO ALL MAJOR MASSES

Mix a large pile of color for the top of the sky using Titanium White, Cobalt Blue, Viridian and a touch of Cadmium Lemon Yellow. That represents the coolest part of the sky. Take some of that cool blue mixture and add a little more Cadmium Lemon Yellow, a touch of Permanent Rose and Titanium White to create the second color mixture. Take a bit of that second color and mix more Permanent Rose and a touch of Cadmium Red into it.

The sky needs to remain fairly neutral, even though it has the blue to blue/green and red to red/violet progression in it. Paint the gradation in the sky from the top down, using the three color mixtures you created and a ¾" (19mm) flat or filbert. Paint the last mixture down to the tree line and adjust the edge so there are soft and hard edges where appropriate.

Next mix Titanium White, Cobalt Blue and Yellow Ochre and paint in the shapes of the house. The roof is a mix of Ultramarine, Alizarin Crimson and Venetian Red. The barn and small buildings are all dark cool reds, grayed with Ultramarine Blue and Titanium White.

Mix Titanium White and Ultramarine Blue with a touch of Cadmium Red or Alizarin Crimson to get a mid-value cool gray for the snow.

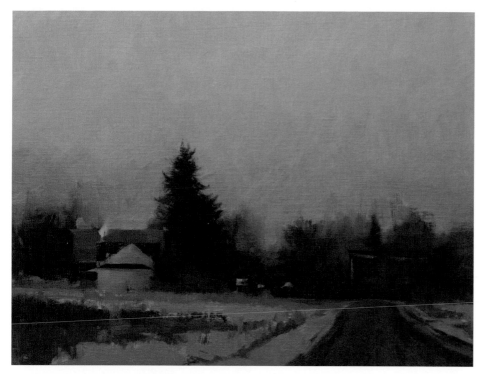

4 CONTINUE WITH THE SKY AND PAINT THE BARN

To reinforce the light coming from left and behind, warm up the left lower part of the sky using a no. 8 flat and a bit of Cadmium Scarlet and Titanium White. The first sky layer is thin and will need to be over-painted with a final layer of finished color that will vibrate from underneath that final layer and add depth.

While the first layer of sky is still wet, work the shape of the largest evergreen tree and correct the drawing of it, working back and forth between the sky and the tree with a ½" (13mm) flat, paying close attention to the character of the individual tree. Work the edge of the tree line as it moves behind the most forward trees. Use cooler grays and softer edges to accomplish that.

The white barn just past the curve of the road balances the farm house on the left and adds a sense of mystery. Instead of making it a white barn as it is in the reference photo, make it a red barn so the value of the red is closer in value to the surrounding woods. Use a no. 8 flat and Ultramarine Blue, Cadmium Red Light, Alizarin Crimson, Venetian Red, Viridian and Titanium White.

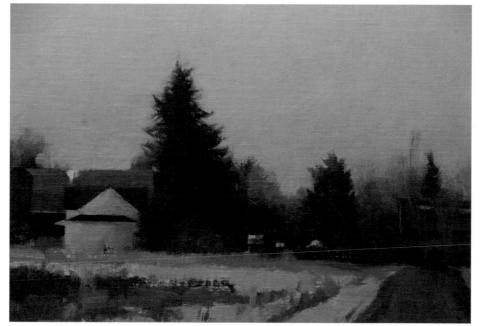

5 FINISH THE SKY, DETAIL THE MIDDLE GROUND, AND REFINE THE EVERGREEN

Once the painting is dry, remix the sky colors and use a soft no. 10 flat to repaint the final layer of the sky. Make any adjustments you feel are needed to make it really sing.

Use a no. 6 flat to add a thin warm reddish mixture to the evergreen tree just off center. Apply it with some OMS if needed, so that it's barely separated in value from the evergreen, and looks as if the sun has risen just enough to catch the top of it with its warm light.

Add some of details to the middle ground area, with the focal point being the peak of the front wall of the farm house. Use a no. 4 sable round to indicate the variety of shrubs, sheds and fencing in this area.

Paint the little sliver of warm light hitting the end of the red barn on the right with some Cadmium Lemon Yellow and Cadmium Red Light.

For additional demos, bios, art and more, visit artistsnetwork.com/oil-painting-with-the-masters.

17

6 REFINE THE TREES AND PAINT THE ROAD

Refine the trees and tree line even further in the area around the barn on the right side using a no. 6 flat and Ultramarine Blue, Cadmium Red Light, Yellow Ochre and Titanium White. Add the fence line on the right side using the same brush. Make the perspective and spacing of the posts look life-like. Take your time and make marks with a small brush at the weed line to let you know how to space the posts.

Where the bare tree branches around the right side of the barn go up into the sky, mix a color and value that is lighter than the darker value of the main dark mass. Use a no. 2 hog bristle filbert and a light touch to pull downward brushstrokes from the top of the shape of the bare branches. Portray the shape of the branches with a dry brush-like stroke, barely depositing paint onto the surface underneath. Your brushstrokes should appear wispy, as if you can see through the multitude of smaller twigs and branches that make up the shape.

Paint the road with a no. 6 or 8 flat. It's a textured road with gravel, rocks, ice and snow. Scrub on the paint in a way that will create a little texture on the painting surface.

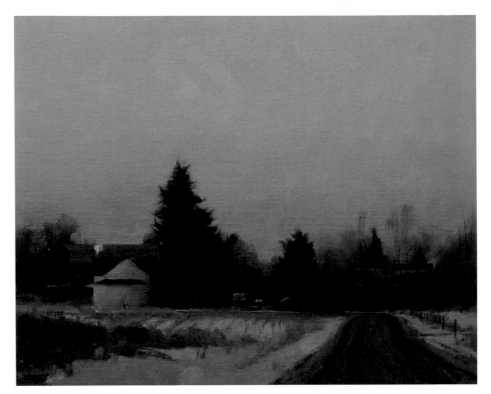

7 PAINT THE ACCESS ROAD AND SIGN

Paint the access road on the right and begin to refine the farm house shapes with a no. 6 flat and the same colors. For the road warning sign, mix Yellow Ochre, Cadmium Lemon Yellow, Cadmium Red Light and some Violet to gray it. Don't make the yellow too chromatic, or it will scream. Pick up the color with a ½" (13mm) synthetic bright. Hold the brush at the angle of one of the edges of the sign and make a slow stroke the width of the sign. Try to paint the shape with one stroke instead of using a bunch of little strokes from a smaller brush. You can go back and refine it later, but go for the big shape first.

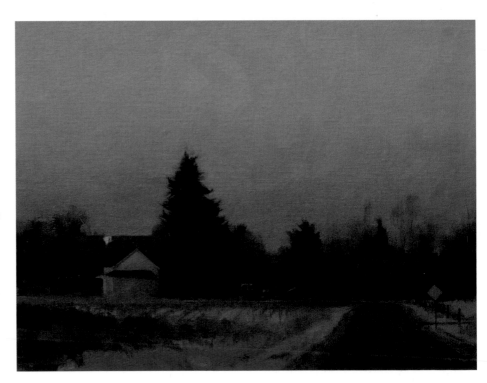

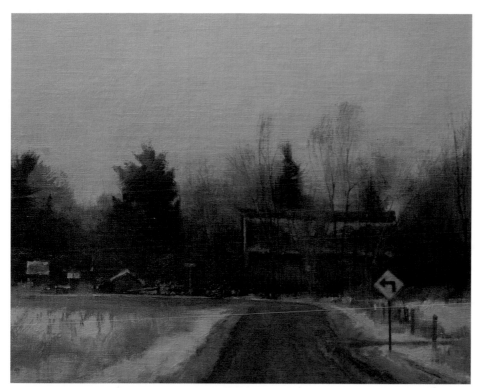

8 ADD DETAIL TO THE SIGNS

Paint the arrow on the warning sign using a no. 2 nylon round and a dark mixture of Ultramarine Blue and Cadmium Red.

For the sign post, use a no. 2 nylon round and paint it in one stroke. You could also use a larger soft flat loaded up with color and touch it to the area so the flat edge creates the post with one touch. Do the same with the green road sign in the back. Mix Viridian and Ultramarine Blue, adding a touch of Alizarin Crimson and Titanium White. Using a no. 6 synthetic flat, pick up the color on the end of the flat side of the brush and touch it to the painting so that you leave a horizontal shape that is nearly the same size as the sign.

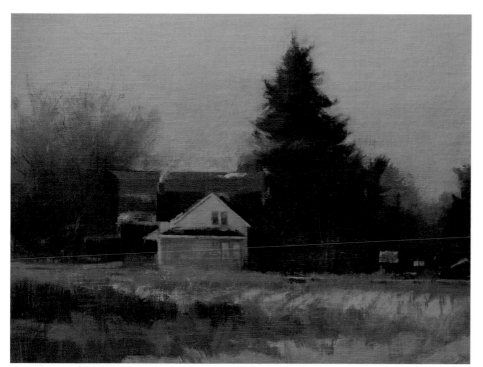

9 DETAIL THE HOUSE AND FOREGROUND

Carefully measure and place the windows in appropriate color and value. Use mixtures of Cadmium Yellow Deep, Cadmium Red Light, Titanium White, Ultramarine Blue Deep and Alizarin Crimson. Pay close attention to the way the windows are strangely offset.

Refine and finish the grasses and snow in the foreground. Mixtures of Viridian, Venetian Red, Cobalt Blue, Transparent Oxide Red and Titanium White in varying proportions will do the job. Grasses are not specific shapes, so use a brush that will help to replicate the helter-skelter nature of this area, like a no. 2 hog bristle filbert. Apply the paint thin and thick, scrape back, and apply more paint. Drybrush over the top of this area with cooler and warmer colors.

Use a no. 8 or 10 hog bristle flat to paint the chimney with a mixture of Ultramarine Blue, Cadmium Red Light and Venetian Red. Then add the smoke, a cool blue mixed from Cobalt, Permanent Rose and Titanium White.

For additional demos, bios, art and more, visit **artistsnetwork.com/oil-painting-with-the-masters**.

19

10 FINISH THE HOUSE AND REFINE THE VEGETATION

Use the same color mixtures as before but vary the values and temperature. With a no. 4 round, finish the porch, the shadow under the porch, the windows and reflecting light in them, and any other details that take the house into the realm of an illusion of reality. Paint an apple tree next to the house, it's branches catching the light of the sun.

Paint the light that's on inside the house with a very tiny dab of Cadmium Yellow Deep mixed with Titanium White and a no. 4 sable round. Adjust the vegetation in front of the house, as needed. Then adjust the color of the light and snow on the roof of the house and the barn using variations of cool shadow colors already used, and the warmer color of the scarlet sunlight.

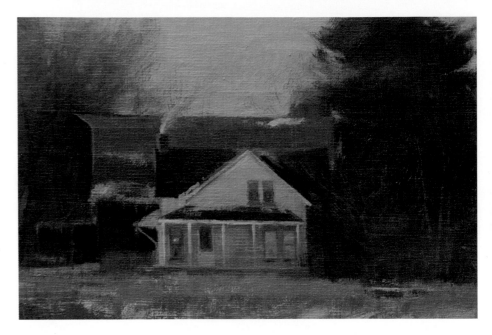

11 ADD FINAL TOUCHES TO FINISH

Add the telephone poles along the road in the middle ground with a no. 6 flat. Paint the poles a cooler gray towards the base as they meet the ground. Then warm up the color with some of that scarlet sunlight at the tops, more on the left sides of the poles than on the right sides. Flatten your brush but retain some color. Touch the brush edge to the canvas to make the vertical shape of the telephone poles.

Use a palette knife to pick up some gray to represent the telephone lines. Touch it to the surface to deposit just enough paint to represent the lines.

Add a glaze of some cooler grays on the road to represent the illusion of tracks and leftover snow on the road. Use a no. 4 bright and some Liquin to accomplish this.

Touch up the grasses along the ditch with a bit of warmer light on the tops of the grass shapes, and correct the snow as it lies in the ditch.

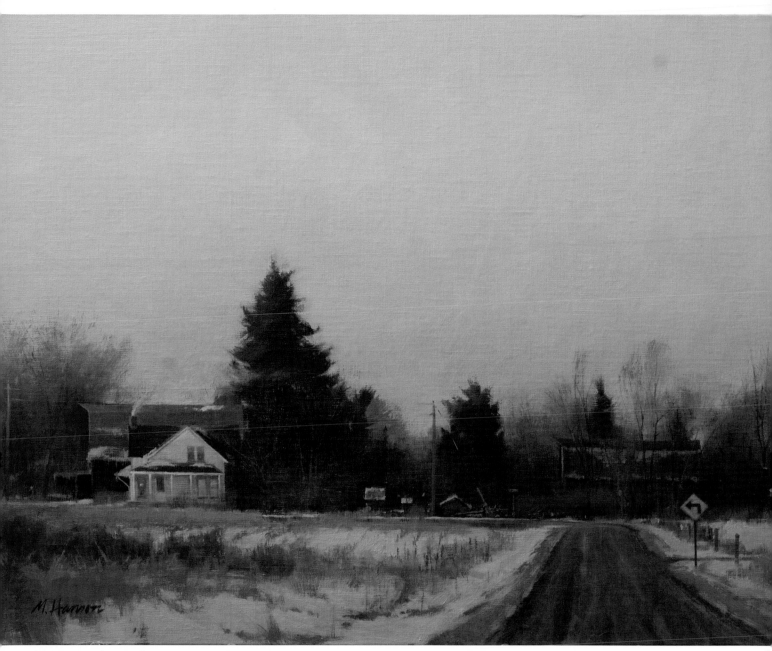

The Atmosphere of Morning Light

Notice the cooling and graying as the color recedes behind the house and barns and into the shadows. Using nearly all cooler mixtures in all of those elements against the warm touches of scarlet and yellows helped to create the atmosphere that Marc wanted to portray. Compositionally and emotionally, the farm house isolated against a cool, dark mass of woodland reinforces the sense of feeling alone and cold.

Teal Avenue
Marc R. Hanson
Oil on linen, 14" × 18" (36cm × 46cm)

To learn more about Marc R. Hanson, his art, video workshops and more, visit:

- MARCHANSONART.COM
- ARTISTSNETWORK.COM/OIL-PAINTING-WITH-THE-MASTERS

2 LIGHT & FORM
with Susan Lyon

"BLESSED ARE
THEY WHO SEE
BEAUTIFUL
THINGS *in humble
places where other
people see nothing.*"

—CAMILLE PISSARRO

Expanding Family
Susan Lyon
Oil on Claessens #13 portrait texture,
20" × 16" (51cm × 41cm)

ABOUT SUSAN LYON

Susan Lyon grew up in Oak Park, Illinois. Her initial interest in art was sparked during high school, upon seeing a television show about Georgia O'Keeffe. "I hadn't seen art like that before. Her work touched me emotionally and seemed so personal—a sort of window into her soul." She got some chalks and started to draw and copy images that she saw in books and magazines. "I didn't know what I was doing. I just liked the tactile feeling of using my hands and getting into a zone of creativity."

Susan studied painting at the American Academy of Art in Chicago and Chicago's over-one-hundred-year-old Palette and Chisel Club. It is there she first began exhibiting and selling her work.

She is inspired by beauty, emotion, color, and people; how light hits a face, a piece of fabric or a vase. "I don't know how to put it into words, that's why I use paint." She draws much of her inspiration from painters such as Anders Zorn, Filipp Andreevich Malavin, Joaquin Sorolla and Cecilia Beaux.

"In the beginning what inspired me to paint was the human form. Through the years I've done still lifes and people in the landscape, but my first love is the lasting one. I paint either the nude figure or a portrait at least once or twice a week. If I could draw from the figure every day I would be happy.

"It's hard to describe how I design a painting. A lot of it is intuition. I try to find balance in shape, value, color and line. There is a lot of trial and error. What I hope to accomplish is to convey the whimsical beauty I see around me as well as make the viewer smile when they look at my work.

"When I started out as an artist, I struggled against my own more feminine tastes. Once I overcame this self-consciousness, I was happy to find that what I enjoy looking at day after day also reaches others."

Susan believes that aspiring artists should paint and draw every day in order to achieve success. She recommends finding people to share the experience with, as the energy of a group of artists working and learning together can often help you improve even faster.

Susan lives in a rural area of North Carolina with her husband, artist Scott Burdick, whom she met at the Palette and Chisel Club. She moved there to escape the hectic pace of city life as well as to experience an entirely different part of the country. Surrounded by nature, her studio allows her the space and privacy to grow as an artist.

Susan Lyon

It also serves as a perfect home base to return to from her painting trips and travels, which have included Mexico, Canada, Peru, Guatemala, and much of Europe, Asia and Africa. "The excitement of traveling, seeing so many new sights and incredible works in museums combined with the challenge of painting on the spot makes me a travel addict. Even before I go on a trip, I'm planning the one after."

Susan is represented by the following art galleries: Sage Creek Gallery, Santa Fe, New Mexico; Insight Gallery, Fredericksburg, Texas; Germanton Gallery, Germanton, North Carolina; and the Sylvan Gallery, Charleston, South Carolina.

For additional demos, bios, art and more, visit artistsnetwork.com/oil-painting-with-the-masters.

23

ON **LIGHT & FORM**

Chiaroscuro is an Italian word that means "light dark." It is used to describe the skillful balance of light and dark in a painting with strong contrasts to create dramatic effect. The paintings of Caravaggio and Rembrandt are good examples.

It is important to keep your shadow patterns simple and solid so the lights of the painting stand out and come forward. If you have too much going on in the shadow patterns, it will distract the eye and make the viewer look into the dark areas.

The brushstrokes that have thickness and color should be in the light patterns to get the Chiaroscuro effect. It is also important to keep the darks thin by using washes so that it looks as though air is going through the shadows.

Practice the technique of painting wet-into-wet to start, then wet-into-dry for finishing touches. You can occasionally thin your oils with odorless mineral spirits to obtain a balance of scratchy brushwork against thick opaque strokes for the lights.

To achieve a realistic style with as much impressionistic color as possible, combine wide brushes for sweeping strokes in the background with small, soft brushes for subtle details in your center of interest.

En Plein Air

"My most memorable plein air experience is when I painted in the Alcazar gardens in Seville, Spain. Artists have to get a signed permission slip by the local government because they are strict about people painting and taking photos in the gardens. I had seen paintings done by Sorolla and Sargent of the gardens and thought it would be so interesting to paint in the same location. The weather was beautiful and because I was by myself, the experience was intense and will stay with me forever."

Susan usually spends about one and a half to two hours on a plein air painting. "I think of them more as color studies, and a great way to gain experience by observing nature."

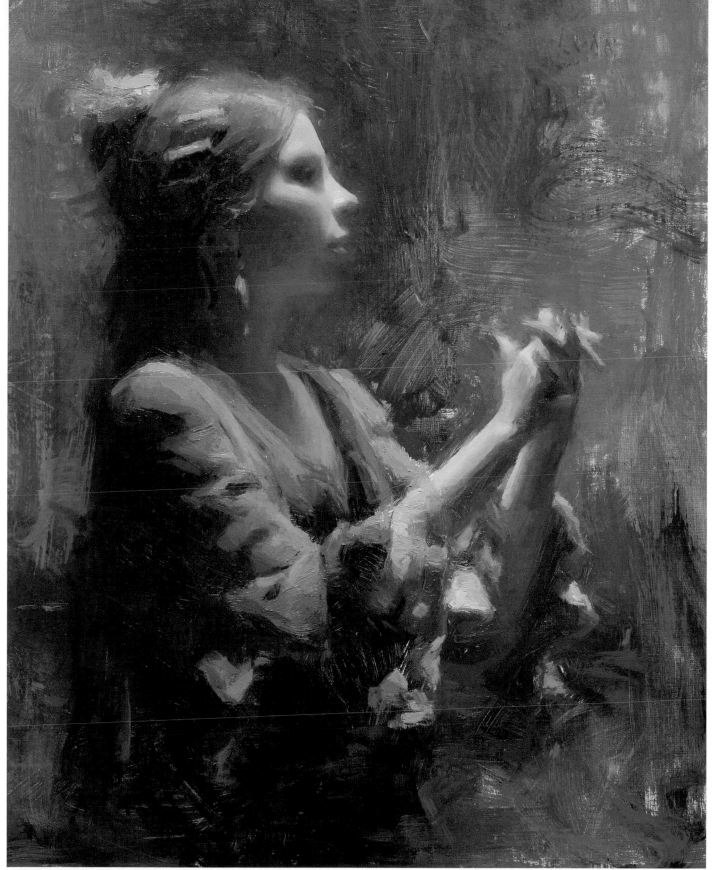

Tone and Shadow in Underpainting
To create an underpainting, Susan tones the canvas with a neutral wash then masses in her shadow pattern.

Clapping
Susan Lyon
Oil on Claessens #13 portrait texture,
18" × 14" (46cm × 36cm)

For additional demos, bios, art and more, visit **artistsnetwork.com/oil-painting-with-the-masters**.

25

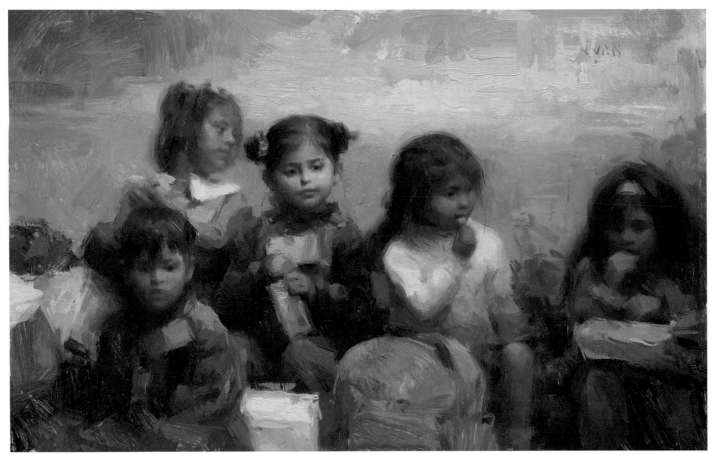

Block in Lights with Thick Paint to Add Texture

Susan washed in her shadow pattern with a bristle brush, then blocked in her lights with thick paint to create texture and interest. She used small nos. 4 and 6 mongoose brushes to paint the lights.

Lunchtime
Susan Lyon
Oil on museum board,
15" × 20" (38cm × 51cm)

Blocking In Portraits with Shadow Color

Susan blocks in her portraits with the shadow color, massing in the large shapes like the hair and the whole eye socket before going into the details. She starts with big shapes, then medium shapes to create the form of the head before using a no. 1 or 2 mongoose or sable brush to pop in the details over the larger shapes.

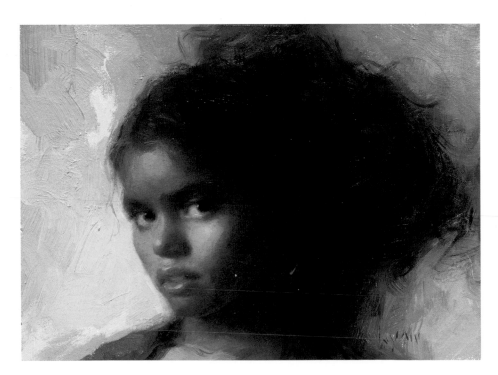

Yanca's Ponytail
Susan Lyon
Oil on museum board, 6" × 8" (15cm × 20cm)

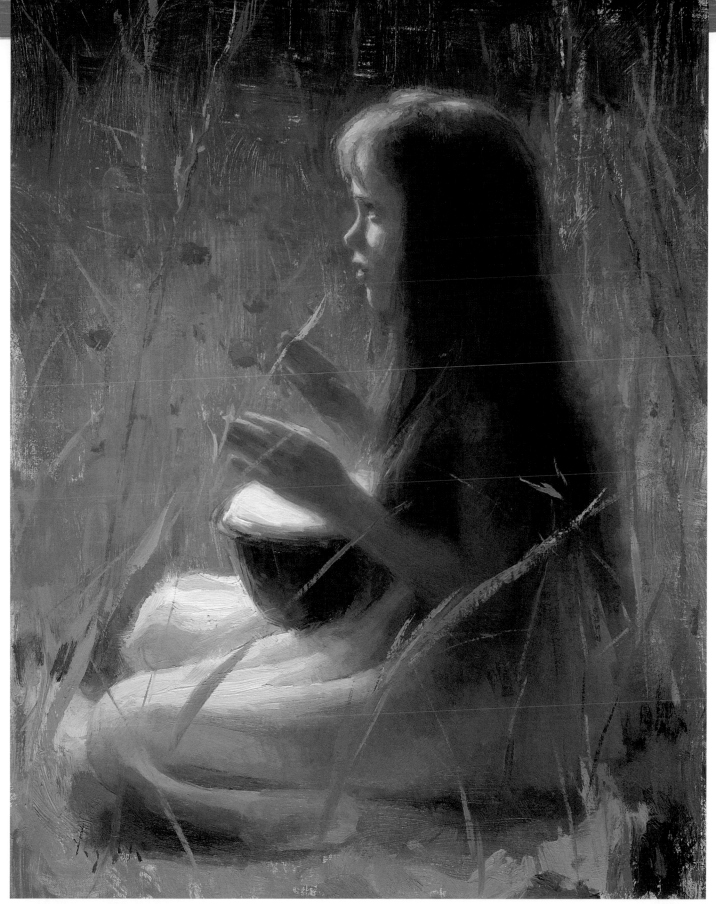

Creating Powerful Light Effects

In order to create powerful light effects in a painting, it is very important to squint and compare your values. This is harder than it sounds—you must determine what your darkest darks and lightest lights are, then work towards the middle.

Maya with Drum
Susan Lyon
Oil on Claessens #13 portrait texture,
16" × 12" (41cm × 30cm)

For additional demos, bios, art and more, visit **artistsnetwork.com/oil-painting-with-the-masters**.

Create Light & Dark Patterns
IN A PORTRAIT

Before an artist starts a painting they must decide what they want to emphasize. Is it the light pattern? Or is it a color harmony? Lyon approached this portrait of the man in the yellow turban with the idea that she wanted to have a strong light-and-dark pattern. A limited palette of Cadmium Red, Ivory black, Transparent Oxide Red and Yellow Ochre was used for this painting, so there are varying mixtures of this for each step.

Follow the steps to learn how to simplify color and create light and dark patterns in a portrait.

Materials

SURFACE

Claessens portrait-texture #13

BRUSHES

nos. 8 and 10 bristle filberts

nos. 4,6 and 8 mongoose filberts

PIGMENTS

Cadmium Red, Ivory Black, Titanium White, Transparent Oxide Red, Yellow Ochre

OTHER

odorless mineral spirits

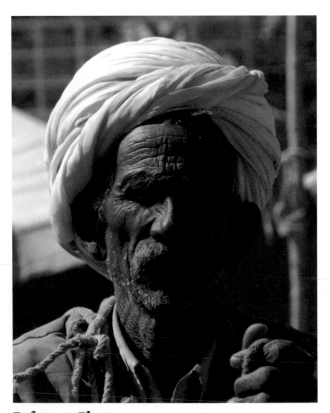

Reference Photo
Susan captured this reference photo on a trip to India.

Value Sketch

1 MASS IN THE DARKS

Tone your canvas with a neutral wash of Ivory Black and Yellow Ochre, thinned down with odorless mineral spirits. Use nos. 8 and 10 bristle filberts to mass in the dark patterns. Squint so you don't see details and make the whole area one large shape and one value. Try to get it dark enough in the beginning so you won't have to darken it later on. That is a problem for most beginning students, and it can take a long time to get over the issue of not wanting to make a skin tone as dark as it should be. You see all the air and colors in the shadow, which makes you want to put more form in the shadow. The only way it will hold together and truly make the lights stand out is for the shadow pattern to stay simple and not distract with too much modeling.

2 BEGIN PAINTING THE TURBAN

Keep your lights untouched and start to add a few strokes of the turban, making sure that the values are the same even if you are using a different color. It is a good idea to mix your colors right next to each other on your palette so you can judge them on your palette before you put them up on your canvas. Use a mixture of Transparent Oxide Red, Ivory Black and Yellow Ochre.

3 ADD THE MIDDLE VALUE FLESH TONES

Mix a flesh color. It should be a middle range value, which would be the color right next to the shadow pattern. Remember that it is still in the light. Sometimes paintings lose the strength of the light pattern because the middle values get too dark and start to blend in with the shadow pattern too much. That is when the strong light-and-dark pattern gets lost. Keep in mind that you want a real definition between where the light shape ends and the shadow pattern begins. Begin applying the flesh tone with a no. 8 bristle filbert. Don't forget to squint the whole time you are looking at the model or reference.

4 ADD MORE MID TONES TO THE FACE

Add some more middle-value flesh colors with a no. 8 bristle filbert. Some are a little cooler and some are a little warmer. Use a mixture of your limited palette for this. The light source is coming from above and to the left, so the cool light will be on the top of the planes of the face, like the top of the cheek and the top of the forehead. Go from shape to shape like a puzzle.

5 BRING OUT THE FORM OF THE FACE

Add a few darks in the cheeks and along the side of the face to the left with a no. 8 bristle filbert. Draw and use value at the same time to bring out the form of the face.

6 BLEND THE SHAPES TOGETHER

Start to use some softer mongoose brushes to knock down some of the texture from the bristle brushstrokes. Try to stay with larger sized brushes like a no. 8 or above until you really need to get into detail. If you start using a small brush you'll tend to get too tight and lose some of the freshness of the brushstrokes. Notice that the dark of the hair and ear go right into the shadow of the turban. Don't define the difference between the two shapes, blend them together.

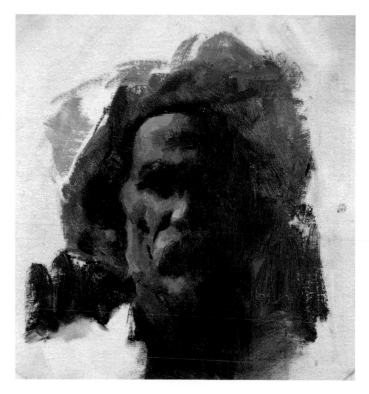

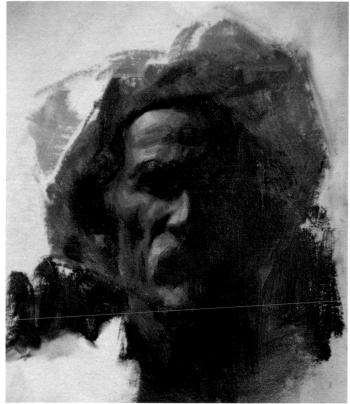

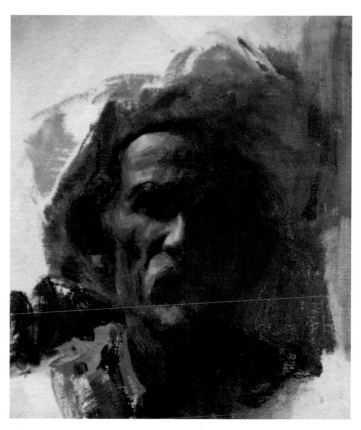

7 DEFINE A FEW OF THE DARKS

Start to see where you can define a few darks like the pupils and the shape of the nostril. You don't want them to come out of that value pattern, so squint and compare. See how dark you should go and then put them in with simple shapes and no detail because you don't want them to come forward. Use a no. 4 mongoose filbert for this.

8 ADD HIGHLIGHTS

Add some of the cool highlights on the forehead and nose using a no. 6 or 8 mongoose filbert. Decide the lightest highlight since the light is coming from above. It will be the top of the forehead. Your darkest dark will be in the hair left of the forehead.

9 PAINT THE TURBAN

Paint the yellow of the turban in using a no. 10 bristle filbert. Even though it is a large light shape, make sure it doesn't compete with the features of the face. You want people to look at the man, not the turban.

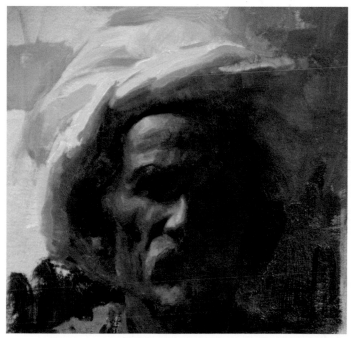

For additional demos, bios, art and more, visit **artistsnetwork.com/oil-painting-with-the-masters**.

31

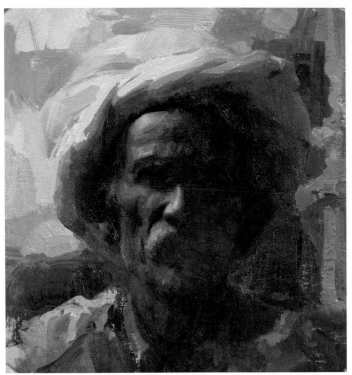

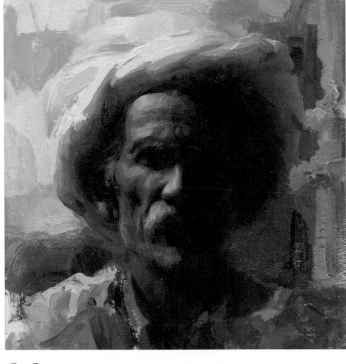

10 PAINT THE BACKGROUND

Add shapes and color to the right of the turban with a no. 8 or 10 bristle filbert. To achieve the juxtaposition of abstract and realistic in this painting, the background should not be done using a realistic technique. Have the bold brushstrokes of the background balance the refined detail in the face. Add some stronger colors along the edge of the shadow patterns with a no. 8 bristle filbert. Put the stronger yellow strokes and the warmer reds along the cheek fold, and paint the shadow along the side of the forehead. Apply the strongest color in small doses just along where the form turns.

11 REFINE THE LIGHT PLANES ON THE FACE

Spend some time refining the planes of the light pattern of the face by putting cooler shapes over warmer shapes. That brings out dimension. Add some strokes to the beard and hint at the eyebrows with a no. 6 mongoose filbert. Make sure the highlights in the beard and chin are not as light as the ones on the nose or forehead.

12 ADD FINAL TOUCHES

Work on the right side of the turban and bring it in a little bit using a no. 8 bristle filbert. Switch to a no. 6 mongoose filbert and add a couple of strokes to the right eye in the shadow while trying to keep it in the socket. If you put too much detail in, it will come forward. Add a few more cool highlights to the cheek and to the shape right next to the neck in the background on the right side to help define it. Darken the upper left corner of the canvas to give the turban an edge. This will also help tone down the shirt and neck so they won't compete with the face.

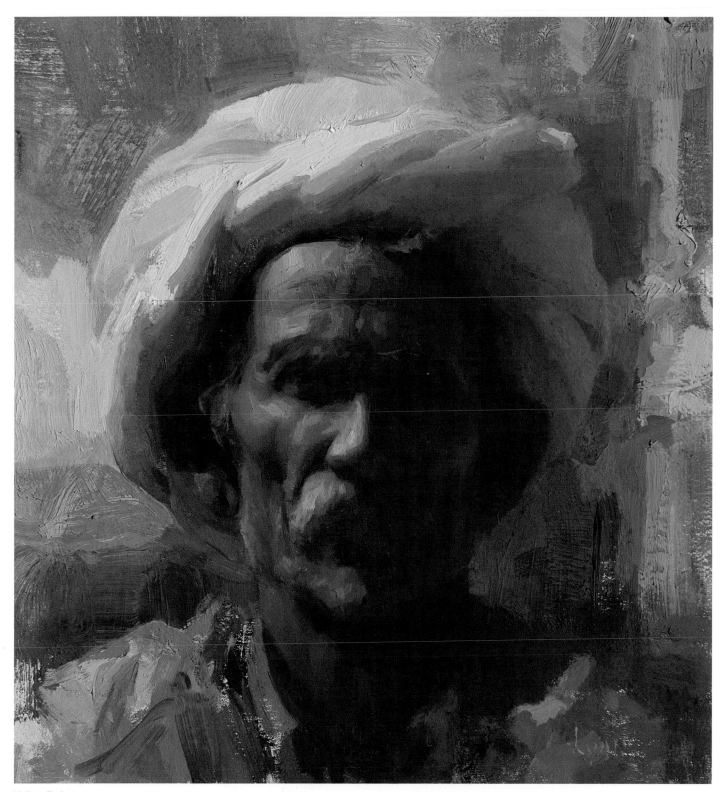

Yellow Turban
Susan Lyon
Oil on Claessens portrait texture #13,
12" × 11" (30cm × 28cm)

To learn more about Susan Lyon, her art, video workshops and more, visit:

∿ SUSANLYON.COM

∿ ARTISTSNETWORK.COM/OIL-PAINTING-WITH-THE-MASTERS

3 COMPOSITION & DESIGN
with Richard McKinley

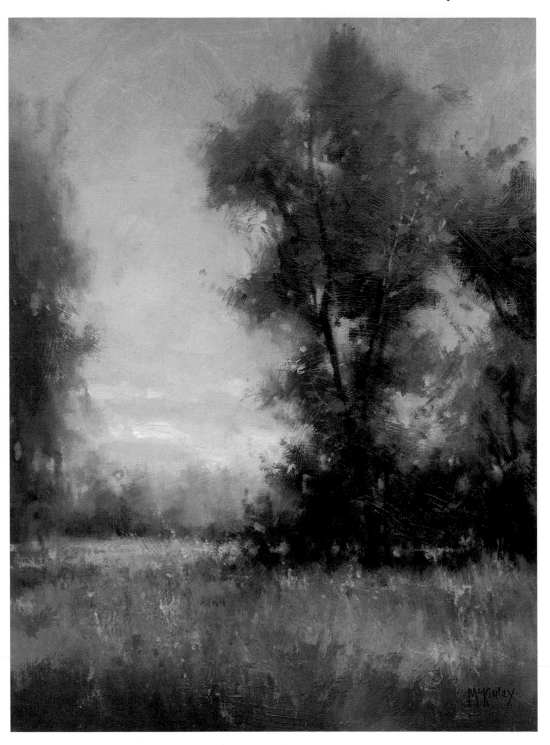

Before the Storm
Richard McKinley
Oil on linen, 16" × 12"
(41cm × 30cm)

"**A PAINTING** *that is well composed is half finished.*"

—PIERRE BONNARD

ABOUT **RICHARD MCKINLEY**

Richard McKinley was born in the Rogue Valley of Oregon, and spent his youth growing up with the rivers and mountains in that area. It is from those subjects that he draws inspiration.

He became passionate about painting around the age of thirteen, but due to his family's economic situation, he did not attend formal art school. He was fortunate enough, however, to have an apprenticeship with James Snook, a professional artist who ran the art department at his high school.

Richard's first mentor was Margaret Stahl Moyer. "She taught me so much. She took me to art galleries, openings and exhibits. And her work was amazing. She gave me critiques, which I didn't appreciate at the time, but certainly do now. She had been trained at the Chicago Art Institute and had been married to Ben Stahl, a renowned American artist."

Years later, it was Richard's good fortune to meet Albert Handell. "I was a huge fan of Albert's work. He saw what I was doing, we instantly took a liking to each other, and a friendship formed. Albert's guidance was very important because it came to me in my adult life, at a point where I needed that first bang to kick me into high gear."

Richard has worked as a professional artist since 1973 and has been teaching since 1976. In 2010, he participated in the American Masters Exhibition at the Salmagundi Club in New York City and was inducted into the Pastel Society of America's Hall of Fame at the National Arts Club, also in New York City.

His work is represented by several national galleries and is in the permanent collection of the Butler Institute of American Art. He is a frequent contributing editor for the *Pastel Journal*.

An avid plein air painter, Richard divides his time between painting the locations he is passionate about, reinterpreting those paintings back in the studio, writing about art matters and instructing workshops.

He believes that by working very closely with nature on location, a much greater appreciation of the natural world and our relationship to it can be achieved.

Winter provides Richard with ample studio time for disciplined study and resolve, but when spring arrives he finds himself eager to pack up his painting equipment.

Richard McKinley

"I want to plant my feet back in the cathedral of nature. This sensibility is the motivation behind every painting. My goal is to capture a piece of the spontaneous dance of light across the palette of nature. I hope my pieces are like a glance when we see something that makes us linger for a moment."

Richard's most memorable plein air experiences have happened at the same spot in the Cascade Mountains in central Oregon. "It's a magnificent area. I discovered it many years ago and I've done probably a hundred paintings in that one spot. It's become like a holy place for me."

Richard has shared his painting techniques on two instructional DVDs, A *Studio Session, Pastel* and A *Studio Session, Oil*, as well as two pastel videos on artistsnetwork.com.

His best-selling book, *Pastel Pointers: Top Secrets for Beautiful Pastel Paintings*, which compiles years of his published "Pastel Pointers" columns and blogs for *Pastel Journal* magazine, was released in 2010 by North Light Books.

For additional demos, bios, art and more, visit artistsnetwork.com/oil-painting-with-the-masters.

35

ON COMPOSITION & DESIGN

When painting, it is easy to become obsessed with the subject matter in front of us to the point where we fall in love with every blade of grass, and it's beautiful. Every leaf is beautiful. Every rock is gorgeous. When we do this, however, we lose sight of the big picture. And that's basically what design and composition are—the big picture; that first impression that hits the audience; the thing they leave with.

Composition signifies the arrangement of the visual elements of design distinct from the subject matter of a scene. Design elements rely on: line, shape, color, value, tone, texture and depth. How an artist uses them helps them to express their ideas and feeling about the scene.

When formulating a composition, begin with a well-positioned and highly defined area of interest. Contrast of edge, contrast of value and contrast of color intensity are the tools that draw attention to the area. The compositional elements of shape and directional flow are others.

Depending on what you wish to communicate to the viewer, raise or lower the placement of the perceived horizon line. A higher horizon line grounds the viewer, making the composition more about the earth. A lower horizon line lifts the viewer's attention above the earth, making the composition more about the sky.

Another useful tool for keeping a viewer's attention within a composition is to orchestrate how the peripheral spaces of the painting are handled. Softening hard edges, slightly darkening value masses, and diminishing color saturation as they travel to the periphery of the composition keep the viewer's attention toward the center space, making it easier to retain their attention. This is a subtle manipulation and need not appear contrived.

Experiment with Design Elements
Every change to a composition has the potential of conveying a different mood or attitude.

- **Line:** Alter the thrust and direction of visual elements within the composition to lead the viewer's attention to certain areas.
- **Shape:** Change the relative width and height of objects to affect scale.
- **Color:** Adjust the dominant color scheme, or weight it toward a warm or cool color bias to affect mood.
- **Value:** Vary the placement of major lights and darks throughout the composition to create importance.
- **Tone:** Modify the saturation of colors for mood and atmosphere. Brighter colors are associated with excitement and joy; grayer tones are calmer and more introspective.
- **Texture:** Accentuate the perception of texture for surface quality.
- **Depth:** Amend perceived distances to convey intimacy or separation.

Experiment with Orientations
The most important lines of a painting's composition are the outside edges. They set the psychological stage for the painting's performance. Basically there are four formats:

- **Horizontal rectangle:** The most traditional for painting a landscape. The horizontal nature relates to the earth's surface and human field of perception. This creates a grounded and calming effect.
- **Vertical rectangle:** The rectangle turned vertically for the landscape allows the viewer's eye to move up and down within the space, creating a forward and backward thrust, similar to a child's swing.
- **Oblong rectangle:** The elongated rectangle creates a sweeping panorama. The viewer pans back and forth across the format, allowing it to impart expansiveness.
- **Square:** The most ambiguous, creating a visual tension, a bull's-eye of sorts, the square often creates intrigue.

Experiment with these formats to gain insight as to how they can strengthen the compositional design. Do an exercise by taking a scene and composing it in each of the formats. You will discover that elements of the design will need to be altered to accommodate the different formats. It can be surprising as to which format stimulates you artistically. It's not that one is better than the other—they just communicate differently.

Brushwork and Placement of Horizon and Masses Creates Interest and a Sense of Intimacy

A higher horizon line was chosen to ground the viewer, creating a sense of intimacy with the scene. The stream's placement and addition of a log along the bank thrust the viewer into the composition. Thicker impasto textures of paint were strategically placed throughout the painting to add visual interest, creating landing points where the viewer lingers.

Cascades Aglow
Richard McKinley
Oil on linen, 12" × 16" (30cm × 41cm)

For additional demos, bios, art and more, visit artistsnetwork.com/oil-painting-with-the-masters.

37

Strengthening a Composition

Many elements of the actual scene were deleted to strengthen the overall composition. The corners were diminished in importance to contain the viewer's attention within the composition. Thicker paint, value accents, and sharper edges were used to indicate the areas of interest. Blue was saturated within the shadows to accentuate the sense of coldness.

Snow Shadows
Richard McKinley
Oil on linen, 11" × 14" (28cm × 36cm)

Downplay Edges to Draw Viewers In

The edges of the painting were intentionally downplayed to allow the viewer to travel back into the composition. The edges of the trees were softened and manipulated to heighten depth of form. The lightest, thickest paint was applied to the area of interest at the bend in the road. An amber tone was echoed throughout the painting to represent the warmth of the light.

Santa Barbara Light
Richard McKinley
Oil on linen, 20" × 24" (51cm × 61cm)

Color and Texture Heighten Depth and Create Movement

Color temperatures were orchestrated from warmer in the foreground to cooler in the distance to heighten the depth of the scene. Textural rhythms and value/color saturations were purposefully placed to lead the viewer from one area of interest to the next.

Last Light Ojai
Richard McKinley
Oil on linen, 16" × 20" (41cm × 51cm)

Use Compositional Choices
TO CREATE AN EXPRESSIVE LANDSCAPE PAINTING

While many painters avoid working from the same reference material, Richard McKinley finds that the more familiar he is with a scene, the more creative and expressive he becomes. Compositional choices are one of the tools he uses to do this.

Follow the steps to learn how to use compositional choices to create an expressive landscape painting.

Materials

SURFACE

oil-primed linen on Gatorboard

BRUSHES

nos. 2, 6, 10 and 12 bristle flats

PIGMENTS

Alizarin Crimson, Cadmium Red Light, Cadmium Yellow Light, Titanium White, Ultramarine Blue, Viridian

OTHER

brush cleaner
Galkyd Lite painting medium
Gamsol odorless mineral spirits
palette knife
paper towels

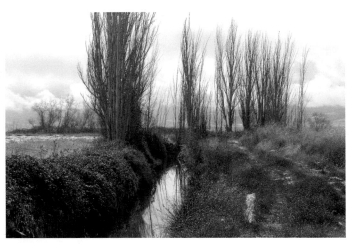

Reference Photo

Composition Sketches

Small thumbnail composition sketches are the foundation of any successful painting. In advance of committing paint to surface, it is always advisable to work out the abstract design elements of large shapes, visual movement and value masses.

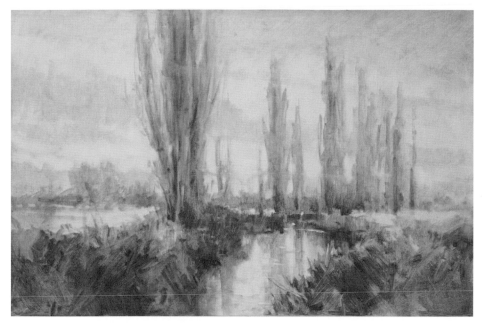

1 TONE THE SURFACE

Tone the surface with a color that represents the color temperature of the light. Even though this is an overcast day, there is a strong amber tone.

Mix a dull yellow color to represent this tone with Cadmium Yellow Light (major amount), Alizarin Crimson and Ultramarine Blue. Use a slightly darker version of the same mixture made with additional Alizarin Crimson and Ultramarine Blue added to the original yellow mixture to indicate the value masses.

Use a mixture of half Galkyd Lite and half Gamsol to stain the surface with a no. 12 flat.

Do not thin the darker mixture. Apply it to the wet surface with a no. 6 flat.

Wipe out lighter sections of the composition with a paper towel.

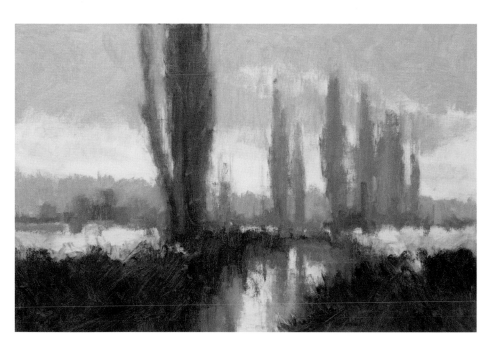

2 BLOCK IN THE DARKS

Use a no. 10 flat and Ultramarine Blue, Alizarin Crimson and Cadmium Yellow to block in the darks, massing them into simple shapes whenever possible. Then migrate to the middle values using a no. 10 flat and white mixed with Cadmium Yellow Light, Alizarin Crimson and Ultramarine Blue to a middle value. A small amount of Viridian and Cadmium Red Light with additional white should be added to vary the appearance.

Fracture the color of the blocked-in masses by adding touches of adjacent colors. For example, if an area is orange in tone, add a few strokes containing more red and others with more yellow. This makes the mass appear more interesting, adding luminosity and life to the painting.

Keep the paint application thin. This makes it easier to apply additional paint. Keep the brushstrokes bold to better convey the gestural attitude of the area. Allow edges to appear soft and somewhat scratchy, making it easier to paint up to them with subsequent applications.

3 BLOCK IN THE LIGHT MASSES AND EVALUATE DEPTH

Begin blocking in the lighter masses in the field and sky with a no. 10 flat. Use Cadmium Yellow Light, Alizarin Crimson, Ultramarine Blue (less), and a touch of white for the field and a large amount of white mixed with very small amounts of all of the tube colors for the sky.

Once finished, evaluate the atmospheric depth of the painting. Make sure that distant areas appear to recede and foreground masses come forward. If they don't appear right, make adjustments by cooling, graying and lightening distant passages or warming, saturating and darkening closer passages. In this case, foreground darks were strengthened. The shapes of objects become more defined and refined during these stages, utilizing negative space by carving in around the tree masses with both the sky and ground.

4 DEVELOP THE TREES AND GRASS AND ADD TEXTURE

Block in the distant field by adding white to the previous field colors using a no. 6 flat. Develop the limbs of the trees using a no. 2 flat with a mixture of Ultramarine Blue, Alizarin Crimson, and a touch of Cadmium Yellow Light. Indicate the textures of the grasses with a mixture of Cadmium Yellow Light, Alizarin Crimson, white, and a touch of Ultramarine Blue using a no. 6 flat.

Switch to a no. 10 flat and a medium gray mixture made with Ultramarine Blue, Cadmium Red, and white to darken the upper left side of the sky. This will add weight and strengthen the overall composition of value. Use the wooden end of a paintbrush to scribble into the wet paint, softening edges and creating texture.

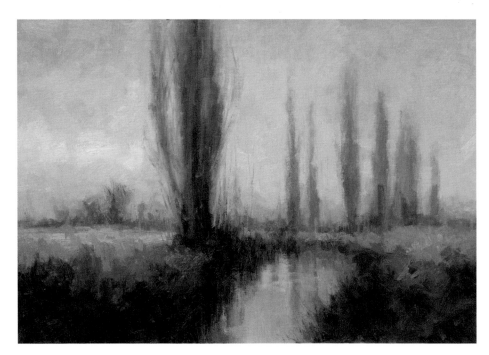

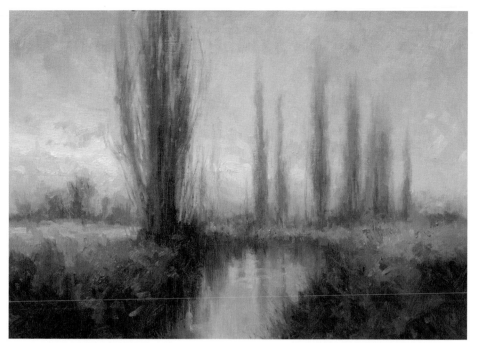

5 ADD THICKER PAINT

Apply a thicker, lighter, brighter paint application around the large foreground tree in the lightest part of the sky with a mixture of white (large amount), Cadmium Yellow, Alizarin Crimson (touch) and some Ultramarine Blue (touch) using a no. 6 flat. This strengthening of the vertical tree mass by the horizontal light area in the sky creates a visual counterpoint to the tree, emphasizing its importance. It also creates more distance between the tree and sky.

Using a no. 2 flat and previous field colors, add thicker impasto paint to sections of the foreground grasses. This will add importance and depth. These passages of thicker textured vegetation become visual landing points within the composition—places where the viewer's eye will linger for a moment before traveling on around the painting.

6 INDICATE TEXTURE

Apply additional accents of impasto paint using previous mixtures throughout the painting with a palette knife to create emphasis. Scratch into this thick paint with a paintbrush handle to indicate texture.

Refine the negative space around major contrasting shapes, such as the trees and water's edge in order to define them better.

Add more detail to objects of interest like tree limbs and individual leaf textures in the grasses. These should be placed throughout the painting in response to the development of the focal areas.

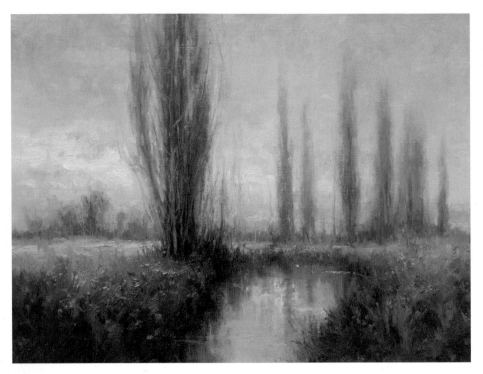

7 REFINE THE PAINTING

Step back from the easel and observe the painting. This is analogous to a conductor listening to the orchestra perform a piece of music before making adjustments. Further refine the foreground vegetation with a no. 2 flat and thicker paint, applied with directional counterpoint strokes to the vertical grasses. Add thicker paint to the sky as well. These impasto paint strokes add visual emphasis and are strategically placed to lead the viewer's eye from one section to another.

Using the chisel edge of a no. 2 flat and a mixture of white (large amount), Cadmium Yellow, Alizarin Crimson (touch), and Ultramarine Blue (touch) paint light shimmers onto the water to indicate the surface as well as create points of interest. Accentuate the cool accents of frozen snow in the distant fields to direct the viewer's attention back to the foreground tree. Distant atmosphere in the base of the mountains should be lightened, especially towards the center right. Strengthen the depiction of the tree trunks and limbs.

Make minor color adjustments and accentuations throughout the composition, such as: pink in the sky, the addition of green in the foreground grasses, and the intensifying of orange in the foreground.

8 MAKE FINAL ADJUSTMENTS

Break the shoreline near the tree by scratching lightly with a paintbrush handle. Then lengthen the shimmer on the surface of the water on the far right, and tweak a few of the tree limbs. When you reach the point of feeling that no additional work will strengthen the painting, you are finished.

The next painting will provide the opportunity for another performance. Painting is a journey, not a destination. Enjoy the process!

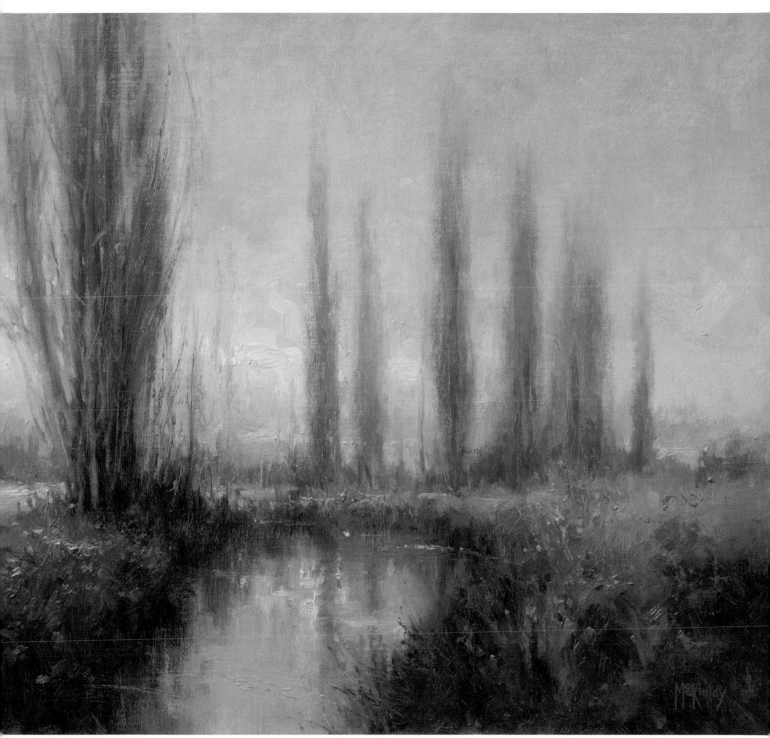

Winter Sentinels
Richard McKinley
Oil on linen, 16" × 24" (41cm × 61cm)

To learn more about Richard McKinley, his art, video workshops and more, visit:

∾ MCKINLEYSTUDIO.COM

∾ ARTISTSNETWORK.COM/OIL-PAINTING-WITH-THE-MASTERS

For additional demos, bios, art and more, visit artistsnetwork.com/oil-painting-with-the-masters.

45

LOST & FOUND EDGES
with Laurie Kersey

Enlightened
Laurie Kersey
Oil on canvas,
30" × 24"
(76cm × 61cm)

"WHERE THE SPIRIT *does not work*
with the hand, there is no art."

—LEONARDO DA VINCI

ABOUT LAURIE KERSEY

Laurie Kersey loves the coastal landscape of the California Monterey Peninsula area that she and her artist husband, Brian Blood, call home. "As they say, 'paint what you love,' and the things that I love are the things that inspire me." Currently, Laurie's work includes the dramatic coastlines and quiet countryside scenes of California—elegant still lifes and florals, figures in quiet moments and horses at work and play.

Much of her inspiration also comes from traveling and looking through books by her favorite painters. "I am often inspired by things I come across in daily life—the roses blooming in my backyard, flowers and produce at the farmers' market, and the horses that I know and love."

Laurie remembers sitting on the floor and drawing horses in crayon as early as the age of six or seven. "The other kids would ask me to draw a horse for them, and I would eagerly do so. Horses are still one of my favorite subjects."

Right after high school, Laurie was awarded a scholarship to attend a summer school for the arts in upstate New York. She then went on to attend the Art Institute of Pittsburgh, where she studied commercial art. After a fifteen-year career as a commercial artist, working as an illustrator and later as an art director on the East Coast, she relocated to San Francisco to study painting at the Academy of Art University. She later taught painting and drawing in the Fine Art Department at the Academy, as well as conducting private workshops near her home on the Monterey Peninsula.

Laurie believes the key to success in painting is to get a good education. "No one would think of trying to become a concert musician without a formal music education, but for some reason when it comes to painting, many people think they can just skip that education part and yet somehow still paint well. My education from the Academy has been invaluable and I would never have gotten anywhere without it."

The personal connections that are often formed with fellow artists and art instructors during the course of pursuing a formal art education are equally invaluable. "I've had two mentors—Craig Nelson, Director of the Fine Art Department at the Academy and my husband, Brian Blood, who I also met there. They're still a big influence on my work and my business."

The most memorable plein air experiences Laurie has had were during her trips to Europe. "My husband and I have

Laurie Kersey

painted in England, Ireland, Scotland, France and Italy. It's not always easy or comfortable. There's often some adventure involved, and the painting doesn't always go well. But they are such memorable experiences that we often end up keeping many of the paintings we do there. We just can't bear to part with them."

Laurie has participated in gallery shows, national juried shows and museum invitational shows, including the Greenhouse Gallery Salon International, California Art Club's Gold Medal Exhibition, Cowgirl Up! Museum Invitational, Maui Plein Air Invitational, Sonoma Plein Air, Carmel Art Festival, and the Oil Painters of America's National and Western Regional Exhibitions.

She has been featured in the magazines *Southwest Art*, *Plein Air Magazine*, *American Artist*, USEF's *Equestrian*, and *Horses in Art*. She was also a first place winner in *The Artist's Magazine's* annual competition.

Laurie is represented by Jones & Terwilliger Galleries in Carmel and Palm Desert, California; K Nathan Gallery in La Jolla, California; Garden Gallery in Half Moon Bay, California; and Fairmont Gallery in Sonoma, California.

For additional demos, bios, art and more, visit artistsnetwork.com/oil-painting-with-the-masters.

47

ON **LOST & FOUND EDGES**

If you are trying to create the illusion of three-dimensional reality on canvas, variation in edges is one of the things that goes a long way in making a painting look real. Without that variation, paintings will look flat, stiff and unconvincing. With a rich variation in edges, your subject will appear more three-dimensional, more painterly, more expressive, more interesting and more alive.

We are speaking, of course, not only about the outer edges of an object, but the myriad edges inside an object—anywhere one tone meets another; where light meets shadow; where one plane meets another.

Often the nature of the elements in your scene along with the lighting will determine which edges will appear sharp and which will appear soft. Hair, fur and clouds will all, by their very nature, have soft edges. The paper-thin edge of a leaf or petal in a still life is often razor-sharp.

The body of a vase as it slowly turns away from you will have softer edges than the lip of the vase in the front. The flesh of a thigh slowly turning away from you will have softer edges than the bones of the knee. Areas which are close in value will appear to have a very soft edge, or no edge at all. Areas of strong value contrast will appear to have a sharper edge.

A distant hill in a landscape will have softer edges than the foreground elements. Fog or haze will soften everything in your landscape. Anything in motion—like the flying hooves of a galloping horse—will only be seen as a blur.

These are, of course, general guidelines to help you understand how the nature of the subject determines the edges. Ultimately, however, you must paint what you see—and you can see edges better by squinting.

Squinting enables you to judge edges more accurately. If you squint you will see more distinctly which edges are sharp, which are completely lost, and which are somewhere in the middle. Look at your subject, squint your eyes, and if you can still see the edge clearly, paint it. If you squint your eyes and the edge disappears, lose it.

Try to establish your edges right from the beginning, usually by softly applying the paint wet-into-wet. Sharp edges are best laid down in one careful stroke with plenty of paint. However, it is much easier to begin soft and sharpen things up as you go rather than beginning sharp and then trying to soften too-sharp edges. There may be times, though, when you'll find it necessary to go back and adjust an edge that is not soft enough. Do this by gently dragging a clean, dry soft brush across the edge or by swiping your finger along the edge.

It is also possible to create the visual effect of a soft edge by laying down adjacent strokes of graduated values, so that when one steps back it appears that the edge is soft, even though each brushstroke is actually distinct when seen up close.

We see our world in stereoscopic vision, which means that we can only focus on one area at a time. It is not possible for the eye to see an entire scene in sharp focus. So it is generally a good idea to reserve your sharpest edges for the focal area of your painting (the area you want the eyes to focus on) and refrain from putting any edges that are too sharp near the edge of the canvas (your peripheral vision). This will help to keep the viewer's eye exactly where you want it within the painting. If you are scrupulous in your observation and implementation of edge variation, you will find that your paintings will be a more convincing depiction of the reality that you see.

When to Stop

"I know my painting is finished when I've fixed everything that was bugging me. First I cover the canvas. Then I refine each area, addressing issues as they come up. Then I adjust anything else that stands out as a problem, and when I run out of things to fix—the painting is finished."

Use Soft Edges for Distant Objects and Hard Edges for Closer Ones
Since our eyes see less clearly in the distance, the edges of the distant hills are painted softer than the hills that are closer. And because of the intrinsic nature of the objects themselves, the edges of the trees and foliage are soft, while the edges of the buildings are fairly sharp.

Days End
Laurie Kersey
Oil on canvas, 11" × 14" (28cm × 36cm)

For additional demos, bios, art and more, visit **artistsnetwork.com/oil-painting-with-the-masters**.

49

Late Afternoon
Laurie Kersey
Oil on canvas, 24" × 36" (61cm × 91cm)

Soft Edges Add to the Perception of Distance

As the line of bluffs runs into the distance, you can see the edges get softer. The distant hill nearly disappears and the clouds are kept soft because of their nature.

Cast Shadow Edges Soften as They Recede

You can see the difference between the hard edges of the structure and the soft edges of the foliage and clouds. The edges of the cast shadows lie somewhere in between, often softening a little as they get farther from the object casting them.

Mission Fountain
Laurie Kersey
Oil on canvas, 10" × 12" (25cm × 30cm)

Soft and Sharp Edges Create Contrast

The edges of the trees are painted fairly soft and the buildings
are painted with sharper edges. Also, the edge of the distant hill
against the sky is kept quite soft.

Ranch House
Laurie Kersey
Oil on canvas, 11" × 14" (28cm × 36cm)

For additional demos, bios, art and more, visit **artistsnetwork.com/oil-painting-with-the-masters**.

51

Explore Edges
IN A FLORAL STILL LIFE

This painting relies on the contrasts of color, value and edges to make the flowers the focus and to create form. To do this, softly render the edges of elements that you want to recede into the background or that are less important, such as the edges of the patterned vase and the vase holding the flowers. Render the important elements you want to bring forward more crisply, such as the central blossoms, select leaves and areas of the silver and glass pitcher and jar.

Although a still life has less depth than a landscape, the principle remains the same: softer edges recede and harder edges come forward. If you put a sharp edge in the center area of an object and softer edges on the sides of that object, it helps give the illusion that the center comes forward and the sides recede, giving the object form. Use this technique in the bouquet of flowers by creating sharp edges to bring the central flowers forward and softer edges to make the flowers in the back or outer areas recede. Use the same technique within each blossom.

Remember, everything in painting is relative, and there are many degrees of softness. It's not about hard and soft, it's about harder and softer.

Materials

SURFACE
Claessens stretched linen, style #9

BRUSHES
nos. 2, 4 and 6 flats

PIGMENTS
Alizarin Crimson, Burnt Umber, Cadmium Red Light, Cadmium Yellow Deep, Cadmium Yellow Light, Titanium White, Transparent Oxide Red, Ultramarine Blue, Viridian

OTHER
Neo Megilp medium
rags
turpentine

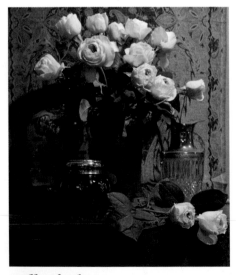

Still-Life Photo
Laurie created this floral arrangement and photographed it for the purpose of showing the actual still life she painted from. She recommends painting from life whenever possible.

Value Sketch
Always begin with a preliminary sketch. Choosing to do a simple thumbnail sketch is a much better idea than creating a large, detailed drawing.

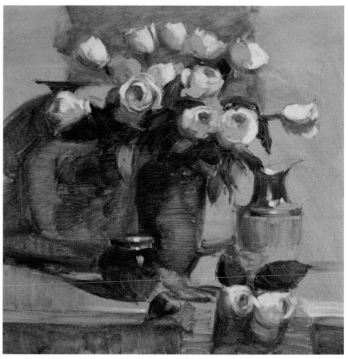

1 TONE THE CANVAS
Begin by toning the canvas with a mixture of Burnt Umber and Viridian. Scrub it on with a rag. Then wipe to an even tone with a rag dipped in turpentine.

2 CREATE A MONOCHROMATIC UNDERPAINTING
Block in the basic shapes with a no. 2 flat and that same mixture of Burnt Umber and Viridian. Use a no. 6 flat to begin blocking in the dark areas using thin, transparent paint.

Dip a rag in turpentine, fold or roll it, and wipe out the light areas. You should end up with a quick, simple three-value monochromatic version of your painting. Once you're satisfied that everything is placed correctly and in the correct value, you can proceed with color.

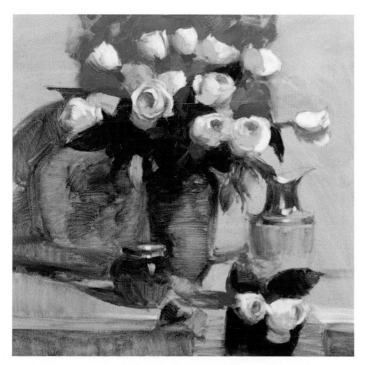

3 BLOCK IN THE LEAVES AND ACCENT FABRIC
Normally you would bring up an entire painting at the same time, but when painting fresh flowers it is necessary to deviate from the normal process and address the blossoms and leaves first before they start to wither and droop.

Begin laying in what lies behind the blossoms, in this case the leaves and the accent fabric. With a no. 6 flat and a mixture of Ultramarine Blue, Alizarin Crimson and Cadmium Yellow Deep, block in the leaves loosely as one large shape. Begin scrubbing in the accent fabric with Ultramarine Blue, Alizarin Crimson, Cadmium Yellow Light and Titanium White, keeping it thin and loose.

You will notice throughout this demo that you're relying heavily on Alizarin Crimson, Cadmium Yellow Light and Ultramarine Blue. By using the same ingredients in most of the painting (in varying mixtures), a color harmony is achieved that is difficult to obtain when you use many disparate ingredients. This is especially important when trying to harmonize a complementary color scheme.

For additional demos, bios, art and more, visit artistsnetwork.com/oil-painting-with-the-masters.

53

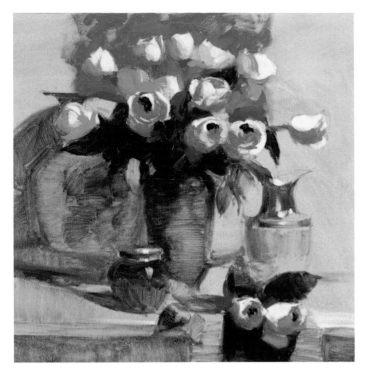

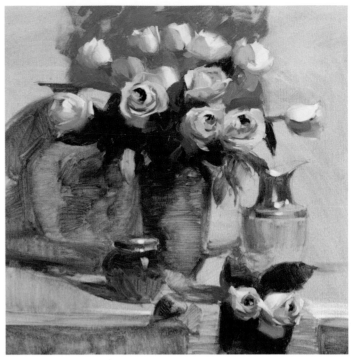

4 PAINT THE BLOSSOM SHADOWS

Now you have something behind the blossoms to compare them with and to help you control your edge variations. Block in the shadow tones of the blossoms with a no. 4 flat and a mixture of Alizarin Crimson, Ultramarine Blue and Cadmium Yellow Light, occasionally adding Cadmium Red or Transparent Oxide Red for the deep centers.

Establish those strong reds first since they are the focal area—you want to keep all the other reds in the painting less intense. Be sure to look for temperature variations and edge variations as you go.

5 PAINT THE BLOSSOM HIGHLIGHTS

Now that the shadows are established, begin blocking in the light areas on the blossoms with a no. 4 flat. Use Cadmium Red Light, Transparent Oxide Red, and Titanium White for the warms; and Alizarin Crimson, Ultramarine Blue, Cadmium Yellow Light, and Titanium White for the cooler tones.

Add the lightest lights with Cadmium Red Light, Alizarin Crimson, and Titanium White. Always look for the underlying shape of the blossom, not the unessential details.

6 PULL OUT HIGHLIGHTS IN THE LEAVES

Use a no. 4 flat to go back into the leaves and pull out lighter areas with Viridian, Burnt Umber, Cadmium Yellow Deep, and Titanium White. Add accents and highlights where you feel it's necessary, and watch for temperature variations.

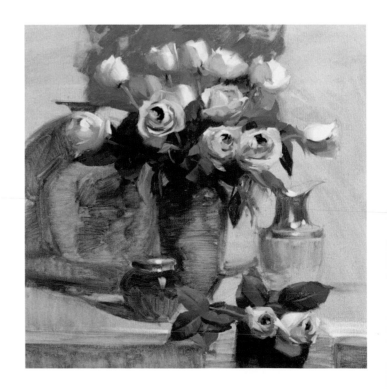

7 BLOCK IN THE BACKGROUND ELEMENTS

Once you're comfortable with the blossoms and leaves, block in some of the other non-perishable items in the setup. Start with the background fabric and the large patterned vase on the left. Use a no. 6 flat and mixtures of Ultramarine Blue, Alizarin Crimson and Cadmium Yellow Light. Paint the vase the flowers are in with a no. 6 flat and a mixture of Ultramarine Blue, Alizarin Crimson and Cadmium Yellow Deep.

8 BLOCK IN THE REMAINING ELEMENTS

Continue to block in the remaining items. With a no. 6 flat, paint the red accent fabric with Alizarin Crimson, Transparent Oxide Red, Ultramarine Blue, and Titanium White. Keep the color intensity muted and be aware of the plane changes in the fabric folds and how the light hits them.

Paint the red glass jar with Alizarin Crimson and Ultramarine Blue. Paint the table with Transparent Oxide Red, Burnt Umber and Cadmium Yellow Light, looking for the flow and dissipation of the light across the surface.

For additional demos, bios, art and more, visit **artistsnetwork.com/oil-painting-with-the-masters**.

55

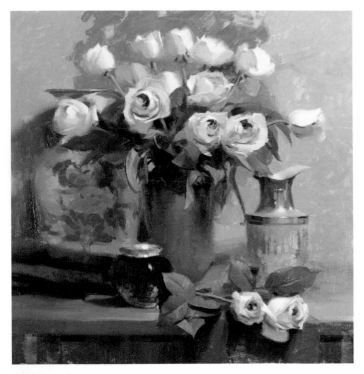

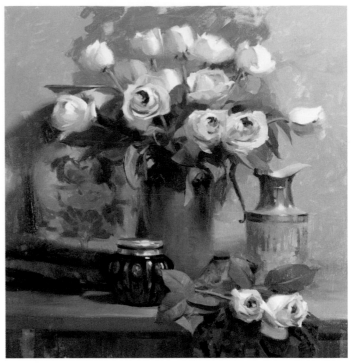

9 REFINE THE VASES AND PITCHER

Once all of the additional background elements are blocked in, go back into each area and refine each object. Begin in the back with a no. 2 flat, using variations of the same colors that you used to block in the vases.

Start with the two vases, and the glass and silver pitcher. Define the pattern on the large vase behind the flowers. Add the cherry detail on the vase holding the flowers. Indicate the cut glass on the pitcher.

Look for color temperature variations, subtle value shifts, reflected color (especially on the silver), edge variations, dark accents and highlights. Since you're now painting over previously painted areas, add some Neo Megilp medium to your paint mixtures.

10 REFINE THE JAR AND FABRIC

Continue to refine the remaining objects by adding an indication of pattern to the red accent fabric with a no. 2 flat and variations of Alizarin Crimson, Transparent Oxide Red, Ultramarine Blue, and Titanium White. Add the cut glass detail to the red glass jar with Alizarin Crimson, Ultramarine Blue and Cadmium Yellow Light.

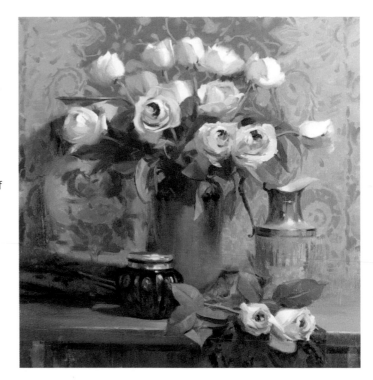

11 PATTERN THE BACKGROUND FABRIC TO FINISH

Go back into the background fabric and add the pattern with a no. 4 flat and Ultramarine Blue, Alizarin Crimson and Cadmium Yellow Light. Remember that the flowers are the center of interest so the pattern needs to be suggested softly and subtly so as to remain in the background.

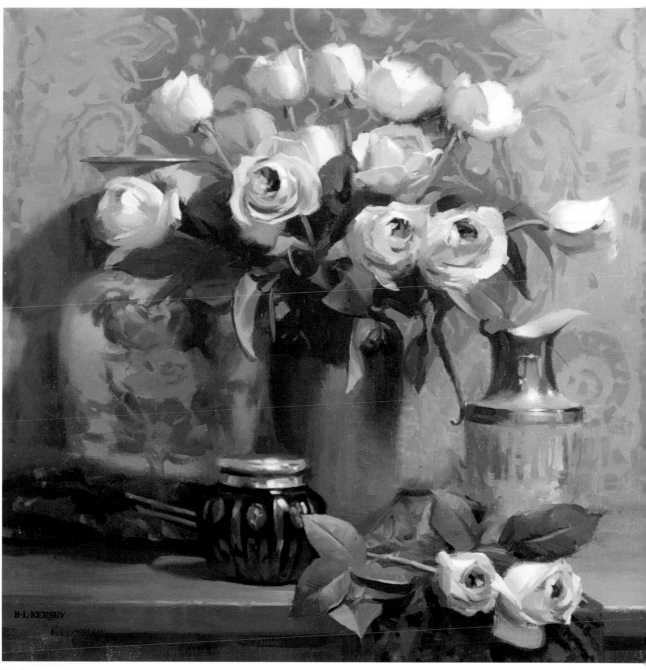

Fresh Flowers
Laurie Kersey
Oil on canvas, 24" × 24" (61cm × 61cm)

THE COLORIST APPROACH
with Camille Przewodek

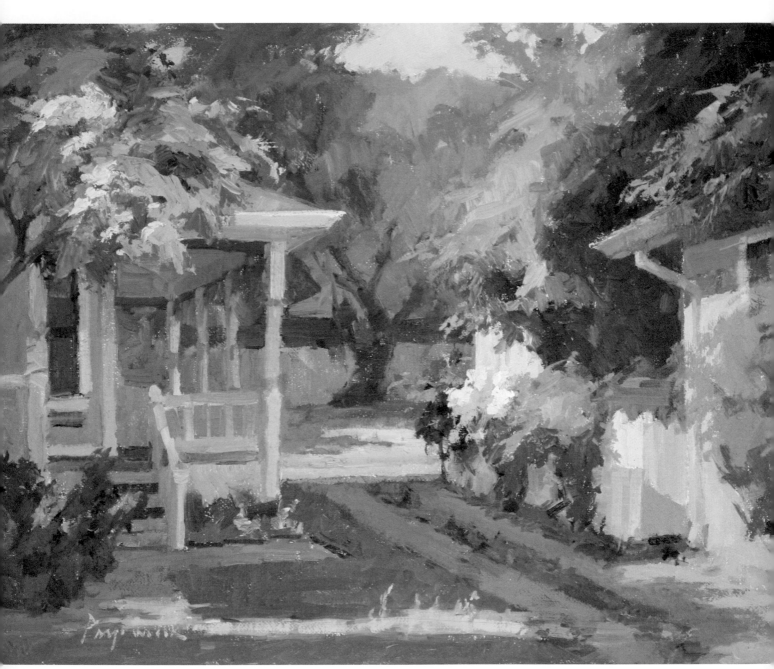

Yard in Back
Camille Przewodek
Oil on canvas, 11" × 14" (28cm × 36cm)

"ANYTHING UNDER THE SUN is beautiful if you have the vision. It is the seeing of the thing that makes it so."

—CHARLES HAWTHORNE

ABOUT **CAMILLE PRZEWODEK**

Camille Przewodek's driving force and inspiration is to pass on what she has been given by all who have come before her. "It's kind of selfish of me because as I give to others, I receive so much more in return."

Camille grew up in Detroit, Michigan, where she was inspired by her artistically talented brother. After graduating with a degree in painting from Wayne State University, she migrated to the West Coast where she eventually earned a B.F.A. from the Academy of Art College in San Francisco. It was there that she met her husband, Dale Axelrod, who introduced her to master painter, teacher and colorist Henry Hensche.

Hensche had been the assistant instructor to famed American Impressionist painter and teacher Charles Hawthorne. He took over the renowned Cape School of Art in Provincetown, Massachusetts, after Hawthorne's death in 1930, in order to continue to develop and disseminate Hawthorne's revolutionary color painting principles. Camille recognized the rare opportunity to study with a true master, and began attending the classes Hensche offered at The Cape School each summer.

While studying with Hensche, Camille's career as a commercial illustrator began to take off. Her fine art training brought her much success, particularly due to her ability to use color, which she had refined through her studies at The Cape School. Her Impressionist painting approach was unique in the field of illustration, and it resulted in landing her many high-end jobs.

After a few years, she grew tired of deadlines and having to spend so much time bidding on projects. So she dropped illustration in order to pursue a career as a full-time fine artist. She hasn't looked back since.

Camille continues to sell her work to collectors knowledgeable in Impressionism and works hard at passing on the Hensche-Hawthorne colorist painting principles to her own painting students. Her greatest joy, however, is that of a plein air painter. "I love setting up on location and capturing a moment in time, using expressive brushwork. I use color and composition to enhance the concept of each painting and to capture the light effect and mood of a scene. My great passion is for being outside, immersed in nature."

Camille Przewodek

For years, Camille imitated what was in front of her in order to learn how to see color. As a mature painter, she often alters what she sees to emphasize the abstract quality of the landscape. "By doing this, I'm not simply copying what's in front of me, but rather orchestrating my paintings in order to enhance my unique viewpoint."

Camille's paintings and techniques have been featured in many books and magazines, as well as on DVD. She is an acknowledged authority on color who regularly serves as an entry and awards judge for various painting competitions and events. She is also a much sought after instructor who teaches annual painting workshops across the country, as well as offering regular weekly classes at her studio in Northern California.

For two consecutive years, Camille has been featured as an on-stage demonstrator at *Plein Air Magazine's* annual Plein Air Convention. She was also an invited instructor/lecturer on the Hensche-Hawthorne Approach to Seeing and Painting Color panel at *American Artist* magazine's Weekend with the Masters.

For additional demos, bios, art and more, visit artistsnetwork.com/oil-painting-with-the-masters.

59

ON THE COLORIST APPROACH

Master painter and colorist Henry Hensche kept the colorist principles of the Impressionist Movement alive and developed them even further. If Hensche had not taken the time and had the perseverance to continue teaching this method of seeing during the Expressionist Movement and throughout his career, the lessons of Impressionism might have been lost. Fortunately, Charles Hawthorne and Henry Hensche have left us a legacy capable of being passed on to future generations.

The best way to understand the colorist approach is to think about it as capturing the effects of light on your subject. Colorists are not so much concerned with painting the objects in front of them as they are with painting the effect of light falling on these objects.

Color Studies

Hensche maintained that color block studies are the most effective way of introducing and developing the colorist way of seeing and painting. These studies can be equated with the scales music students are expected to practice and perfect during their lifetime as musicians. For the colorist, color block studies are "color scales" that allow one to concentrate on developing the ability to express nature's different light effects through accurate color relationships.

Color Study Process

1. Ideally, your first color block study would be done in full sunlight, where the light effect can be seen as a pattern of clearly defined surfaces that are either in light or shadow. (Beginners may need to make repeated attempts before becoming comfortable with recording the brilliance of the sunlight.)

2. The next step would be to do a color study under cloudy (or *gray day*) conditions.

3. When you are able to paint the difference between a sunny day and a gray day, try to capture the different light effects present at different times of day—early morning, late afternoon, midday, etc. Exaggerate the light effects through distinctive hues, as well as through values and degrees of saturation.

Eventually, with time and study, your color tones will become more and more refined. What you learn from these simple color studies can be applied to whatever subject matter you wish to paint.

Artistic Influences

Camille is most inspired by Claude Monet. "My teacher, Henry Hensche, is a direct heir to Monet's tradition. I believe Hensche actually surpassed Monet in his ability to paint the light effect of nature. And he taught me how to capture that light effect. If he had not kept this movement alive, what Monet started would have died out. Fortunately, Hawthorne and Hensche kept it alive and developed a way of teaching this way of seeing."

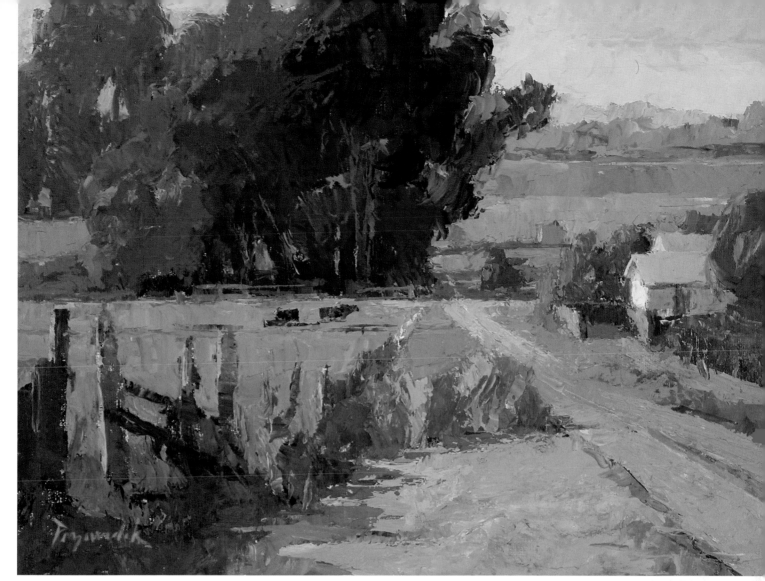

Use a Full Range of Colors

It was the invention of the paint tube that first allowed artists to go on location to paint. As technology has improved so have pigments, making it easier to get closer to capturing nature's light effects. The vast range of pigments available today is what allows us to convey the varied light effects of nature. So don't shy away from using a full color range in your paintings.

Petaluma Pasture
Camille Przewodek
Oil on canvas, 11" × 14" (28cm × 36cm)

Color Study by Camille Przewodek

Color block studies should present uncomplicated subject matter, allowing one to easily see simple plane changes and the division between light and shadow. By taking everything else out of the equation (picture making, composition, literary content, etc.), you can focus exclusively on the pure visual experience of the particular light key you're presented with.

For additional demos, bios, art and more, visit artistsnetwork.com/oil-painting-with-the-masters.

61

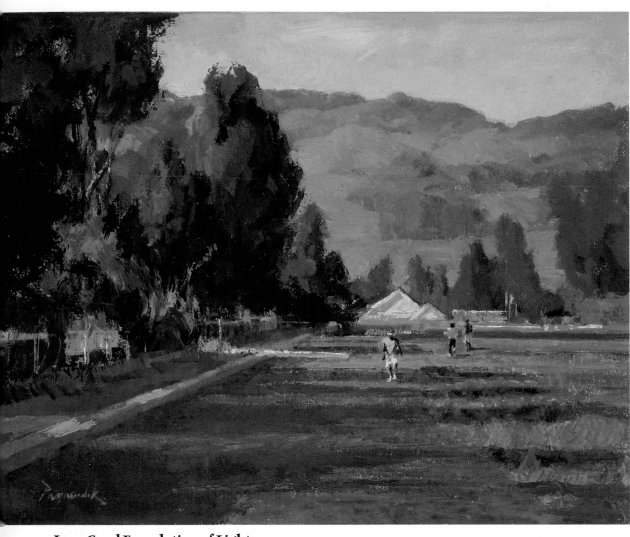

Late Evening Jog
Camille Przewodek
Oil on canvas,
16" × 20" (41cm × 51cm)

Lay a Good Foundation of Lights and Darks

Organize your lights and darks in the initial lay-in. That initial lay-in is the skeleton of the final painting. Under every good painting is a good abstract composition.

Push Nature's Light Effects

Use light effects to try to move the viewer through the painting. Push the illusion of light. Overstate its warmth.

Afternoon Path
Camille Przewodek
Oil on canvas, 11" × 14" (28cm × 36cm)

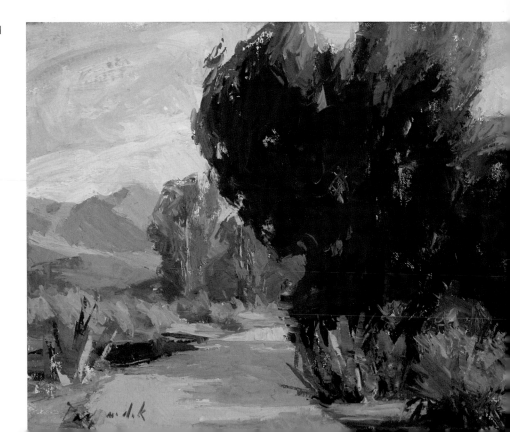

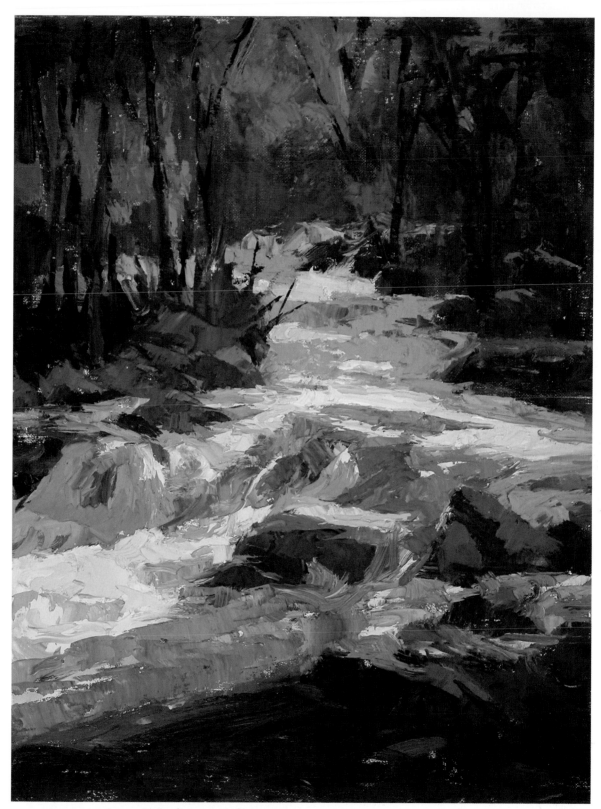

Cascading Water
Camille Przewodek
Oil on canvas,
16" × 12"
(41cm × 30cm)

Exaggerate Light and Shadow with Pigment

Exaggerate the warmth of the light and the coolness of the shadow with pigment. Remember, you are painting the warmth of the sun. You have to warm up the light plane and cool the shadow notes. Even on a gray day when the values are closer together, use temperature changes to indicate the light-and-shadow relationship. The light planes on a gray day are cooler, the sky is warmer and the shadows are warmer.

For additional demos, bios, art and more, visit **artistsnetwork.com/oil-painting-with-the-masters**.

63

Create a Painting
USING A COLORIST APPROACH

The house in this painting is essentially a block study in the landscape — a perfect subject for studying the envelope of light. Follow the steps to create a painting using the colorist approach.

Materials

SURFACE
white gessoed board

BRUSHES
no. 4 filbert
no. 1 round

PIGMENTS
Cadmium Green Pale, Cadmium Orange, Cadmium Scarlet, Cadmium Yellow, Indian Yellow, Lemon Yellow, Permanent Alizarin Crimson, Permanent Magenta, Titanium White, Ultramarine Blue, Viridian, Windsor Red, Yellow Ochre Pale

OTHER
Liquin
odorless mineral spirits
pallette knife
paper towels
pastel pencil (light blue)

Reference Photo
This is the house Camille was inspired to paint. She liked the light and dark patterns and all the flowers that surrounded it. It wasn't the prettiest house on the block, but it had some good shapes, and Camille felt she could redesign much of what was in front of her.

Value Study
Because Camille's plein air colorist approach focuses on capturing light effects through accurate color relationships, she starts her paintings directly, considering all three aspects of color (hue, value, and saturation) simultaneously. She emphasizes that value alone is insufficient to most effectively simulate the dynamic range of nature. Her full-color start reveals that she has also considered value in establishing her initial composition.

1 MASS IN THE BIG SHAPES

Sketch the subject onto a white gessoed board using a light blue pastel pencil. By using a pastel pencil it will be easy to erase mistakes with a paper towel and your colors will remain fresh as you lay the paint down on top of your sketch. It is important to determine where the horizon line is so that everything will be in the proper perspective.

Pay particular attention to the house's ground line, which, although unseen, will help you establish the surrounding foliage and sidewalk in correct perspective.

2 LAY IN THE FIRST COLORS

Begin the painting with a no. 4 filbert, using a little bit of Liquin to make your paint flow more easily. Use Ultramarine Blue, Titanium White and a touch of Cadmium Orange for the first color note—the front side of the house in shadow.

The next color note will be a mixture of Cadmium Orange and Yellow Ochre Pale. Apply it to the section of roof that is in the light. Add some Windsor Red to that mixture and paint the section of roof on the right. It is still in light but is a bit darker and cooler.

Move across the painting from one adjacent color to the next, to ensure the accuracy of all the relationships.

Note: It is critical to keep your brushes clean throughout your painting session. If you use a palette knife, it will be easier to keep your colors clean. With brushes, you should constantly keep cleaning them in mineral spirits and wipe them clean with a paper towel before moving on to the next color.

3 CAPTURE THE LIGHT EFFECTS

Using a no. 4 filbert, work from one adjacent note to another. Paint a darker note indicating the shaded area of the inside of the porch with some Ultramarine Blue and Cadmium Orange. The color of the wall to the left is a mixture of Ultramarine Blue and Viridian. Start the bush in shadow with Permanent Magenta.

Use a mixture of Cadmium Yellow and Cadmium Green Pale for the light part of the bush. Remember that you are trying to capture the general light effect, so don't worry about details such as flowers at this point.

As you paint, ask yourself, *Is it lighter or darker, warmer or cooler, brighter or duller?*

4 PROCEED WITH INITIAL COLOR STATEMENTS

Paint the trees behind the house with a cool purple using a mixture of Permanent Alizarin Crimson and Ultramarine Blue. Because these two colors share red, you'll get a clean purple. Be careful not to repeat the same colors, as you want to paint the difference between all the colors. Later, you will add the local colors (actual color of things) into these initial color statements.

Try to think about one brushstroke that leads into another and takes the observer through the painting.

5 ESTABLISH WARM AND COOL COLORS

Continue using the no. 4 filbert to paint the sidewalk in light and shadow. Mix a dark warm tone with Cadmium Scarlet, a touch of Yellow Ochre Pale and Titanium White to paint the light part of the pavement. The bushes on the left are cooler, so paint them with Ultramarine Blue to distinguish them from the warm bushes on the right side of the porch. Use some Cadmium Scarlet for part of the flowers in light.

6 FINISH LAYING IN THE FOREGROUND AND MID GROUND SHAPES

Finish laying in all masses except the sky. These masses should be stated as simply as possible, keeping detail to a minimum. You will go back later to add the detail. Paint the trees in the back left with a mixture of Yellow Ochre Pale and Ultramarine Blue, varying the amount depending on whether the bush is in light or shadow.

For additional demos, bios, art and more, visit **artistsnetwork.com/oil-painting-with-the-masters**.

67

7 PAINT THE SKY

Use a no. 1 round and a palette knife to add the color of the sky by using Titanium White with some Windsor Red. This warm note helps emphasize the brightness of the sky and differentiates it from the bluish color notes in the shadow areas of the house.

After you have covered the canvas, step back and take a rest and just look at what you have done. Ask yourself if you have organized all your lights and darks. Have you captured the right light effect? Does it look like the house and surrounding bushes are in warm morning light?

8 REFINE THE PAINTING

Reconsider the various notes you laid down in your initial statement, refining the colors and adding more details while still maintaining the strength of the light effect as your primary focus. Mix a cool green color with Viridian, Lemon Yellow and Indian Yellow. Add it to the Permanent Magenta that you put down initially to paint the bush on the right in shadow.

Add some flowers to that bush so you see some pink in sunlight and some cooler red in the shadow of that same bush. For the cool red of the flowers, use a mixture of Windsor Red and Permanent Magenta. Cool the sky by adding some blue tones in the same value.

Refine the foliage and details on the house. Transition colors from light to shadow and bring the colors together, getting rid of all the white spaces. You should also consider reflective light at this stage.

9 COOL DOWN TO FINISH
Cool portions of the roof that are not in full sunlight by adding some blue tones so it does not look so orange and more accurately indicates the reflection of the sky overhead. Break up the big masses of the bushes and paint the various plane changes, some of which are cooler if they face the sky, perhaps warmer if they face a warm grass or flower. Cool the lawn by adding some blue or cooler green tones.

Corner of Light
Camille Przewodek
Oil on gessoed board
11" × 14" (28cm × 36cm)
Collection of Ellen McCay

To learn more about Camille Przewodek, her art, colorist approach demonstrations and more, visit:

∾ PRZEWODEK.COM

∾ ARTISTSNETWORK.COM/OIL-PAINTING-WITH-THE-MASTERS

MASSING SHAPES
with Jeffrey R. Watts

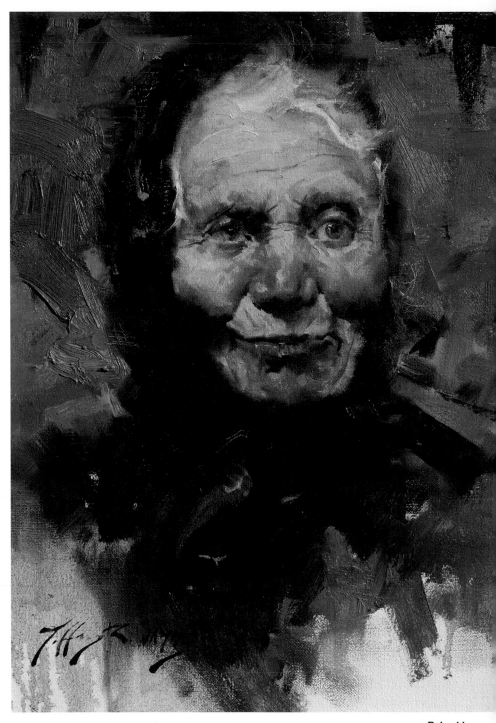

Babushka
Jeffrey R. Watts
Oil on linen, 16" × 12"
(41cm × 30cm)

" **THE OBJECT
ISN'T TO MAKE
ART;** *it's to be in
that wonderful
state which makes
art inevitable.*"
— ROBERT HENRI

ABOUT JEFFREY R. WATTS

Jeffrey R. Watts has had a compulsion to create art as long as he can remember. He was held back in the first grade because he would not complete the required assignments, refusing to do anything but draw. He would later go on to excel at academics, as well as competitive sports. After an injury cut short his budding career in professional cycling, however, he turned his focus back to art.

Jeffrey enrolled at the California Art Institute in Calabasas, where renowned instructors Glen Orbik, John Asaro and others had been influential in training masters such as Jeremy Lipking, Morgan Weistling and many more of today's most noteworthy painters. "I believe the most important thing art students can do to achieve success is to find a school where they can truly master the fundamentals and train in all the major areas until they reach an intuitive level."

Although he feels fortunate to have studied under many influential instructors at the California Art Institute, Jeffrey credits his father, who is an illustrator and fine artist, as his greatest artistic mentor.

Jeffrey began to teach at the Institute after a few years there and about that same time started to work as an illustrator in the movie industry. However, his goal to become a fine artist took him back to his native San Diego, where he opened a small life drawing and painting studio called Watts Atelier of the Arts.

Jeffrey's aesthetic sensibilities have long drawn him to the figurative art of nineteenth century Europe, particularly Russia. His Atelier allows him to work regularly from the live model, grounding his work in traditional principles.

"I have many passions that fuel my art." Traveling and experiencing different cultures and places was a great inspiration to Jeffrey in his early years, and still is, although he finds it more difficult to break free to travel nowadays. "I find people, especially portraits, to be of great interest. I also find that working between all the major disciplines of art helps prevent burnout. It promotes subtle growth that would normally go undiscovered, much the same way a professional athlete may train in many different fitness endeavors to help prevent injury and staleness."

Recently Jeffrey's work has been compared to that of Nicolai Fechin, an influence he is quick to acknowledge. "I never grow tired of looking at the work of Nicolai Fechin. His work is the perfect combination of control and chaos." In 2008, the

Jeffrey R. Watts

Taos Art Museum and Fechin House honored Jeffrey with a solo exhibition in the original home and studio of Nicolai Fechin.

Jeffrey has also won numerous awards for his paintings, including first place in the portrait category and second place in the landscape category from *The Artist's Magazine*; two second place awards at the Salon International Exhibition; an Honor Award and an Award of Exceptional Merit from the Portrait Society of America; and three Awards of Excellence from Oil Painters of America.

His work has been featured in the magazines *Southwest Art, American Artist, Art of the West, Western Art Collector, American Art Collector, American Artist Drawing* and *American Artist Workshop*.

A Master Signature member of Oil Painters of America, Jeffrey is also a Signature Member of both the Laguna Plein Air Painters Association and the California Art Club. He holds membership in the Portrait Society of America as well.

For additional demos, bios, art and more, visit artistsnetwork.com/oil-painting-with-the-masters.

71

ON MASSING SHAPES

There is a specific style of laying in shapes that uses a rhythmical grid system called *the abstraction* to navigate a composition's masses in a systematic manner.

During this abstraction mapping phase, use a primarily linear approach, keeping your linework very light and noncommittal. Track along the subcutaneous surface, bone protrusions and muscle rhythms. This system is based in a very thorough understanding of human anatomy and can take many years to master, so don't be discouraged if you aren't able to perfect it right away.

The mapping phase somewhat occurs along with the abstraction and helps to simplify and lock down your key shapes. Once this phase is complete, you can then move on to the next step of laying in middle values and finally, rendering the painting to a finish.

Learn to manipulate what you see, and not be manipulated by what you see. It is a far more enjoyable way to work and opens the door to more individual expression. When in doubt, leave it out. The true art is in the simplification, not the complication.

In the Studio

In order to create powerful light effects in paintings, Jeffrey believes the key is to keep your values under control and to use abstractions of colors vibrating off of each other to give the illusion of reality. He loves the work of artists like Fechin, Sorolla and Zorn for these reasons. "There are so many others that possessed this uncanny ability to manipulate their sparse colors to represent the awesome effects that nature does so effortlessly."

Since he enjoys experimenting with color, Jeffrey's palette is constantly changing. "I have a warm/cool basic palette, but my supplemental colors change frequently as I try out new color combinations."

He uses a variety of both sable and bristle brushes. "I like the old Langnickel brushes the best, but I am always trying out new brands to see if I can find anything I might like better. So far I haven't. I still prefer the Langnickels."

Jeffrey likes acrylic-primed and alkyd-primed surfaces, but oil-primed linens are his favorite support. He loves the way the linen takes the paint. This is an area he has spent a great deal of time exploring. "I often prepare my own textural lead canvas surfaces. It's a true art and should not be attempted unless you're very knowledgeable about the hazards of soluble lead."

Map, Mass and Refine

When designing a composition, Jeffrey usually begins by sketching with a ballpoint pen or a drafting pencil to map out and mass the shapes, explore the subject and flesh out the pictorial arrangement. He then moves on to some small thumbnail studies in gouache before finally refining the composition freehand.

Farrier
Jeffrey R. Watts
Oil on linen,
60" × 40"
(152cm × 102cm)

For additional demos, bios, art and more, visit **artistsnetwork.com/oil-painting-with-the-masters**.

73

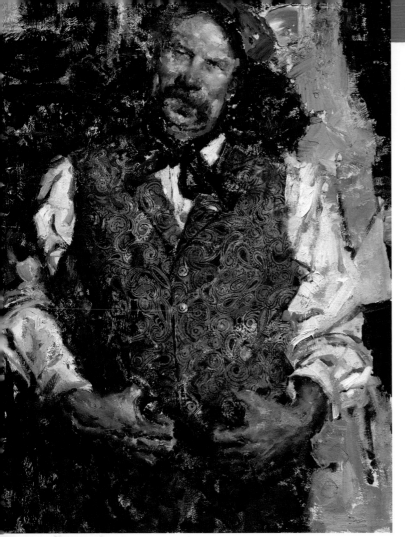

Massing in the Big Shapes

By simplifying and massing in the big shapes, you will bring order out of disorder and confusion. Large simple shapes convey the nature of a subject better than its details ever could.

The Irishman
Jeffrey R. Watts
Oil on linen, 24" × 18" (61cm × 46cm)

Shapes and Patterns

Seeking out the basic shapes and patterns in your subject is the first step in creating good form and structure.

Katrina II
Jeffrey R. Watts
Oil on linen, 23" × 17" 58cm × 43cm)

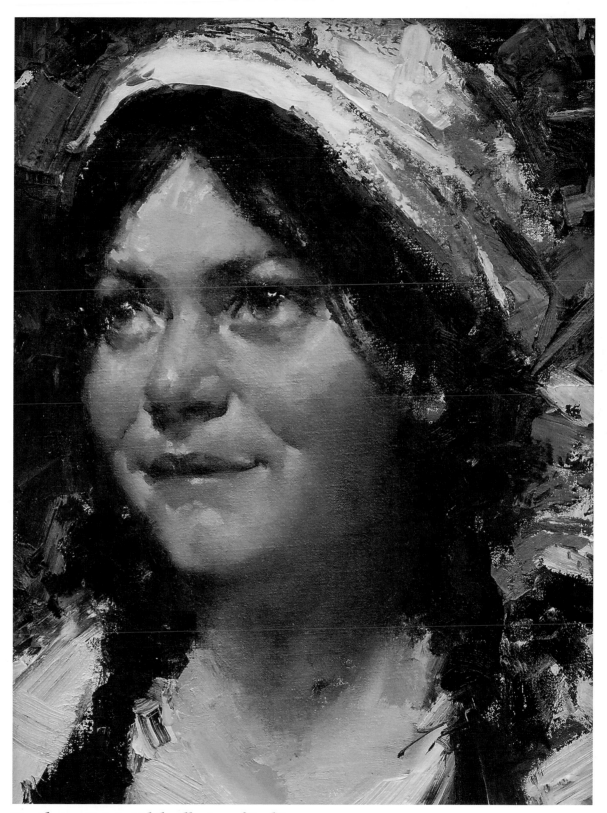

Charlotte
Jeffrey R. Watts
Oil on linen, 12" × 9"
(30cm × 23cm)

Use Abstraction to Aid the Illusion of Reality
Create powerful light effects in a painting by keeping values under control while using abstractions of shapes and colors vibrating off of each other to give the illusion of reality.

For additional demos, bios, art and more, visit artistsnetwork.com/oil-painting-with-the-masters.

75

Simplify & Mass Shapes
IN A PORTRAIT

When creating any work of art it is extremely important to pay special attention to the simplification and massing of your primary and secondary shapes. When painting or drawing, it is particularly important to squint way down. This allows you to remove any superficial information that doesn't need to be there. Once you have laid in your composition by simplifying and massing in the shapes, you can start moving around the piece, adding subsequent layers of half tones and cross contouring as you see fit.

Follow the steps to create a portrait by simplifying and massing the shapes.

Materials

SURFACE

gessoed panel

BRUSHES

nos. 6 and 8 bristle filberts

no. 8 bristle flat

no. 6 sable round

PIGMENTS

Alizarin Crimson, Cadmium Red Light, Cadmium Yellow, Cadmium Yellow Light, Cobalt Blue, Ivory Black, Olive Green, Titanium White, Transparent Maroon, Transparent Oxide Red, Ultramarine Blue, Yellow Ochre

OTHER

Gamsol (as a brush cleaner only)

palette knife

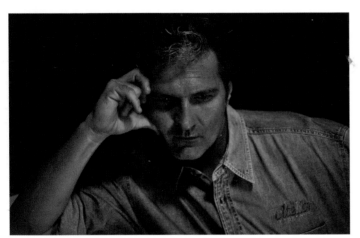

Reference Photo
Jeffrey photographed himself for use in this step-by-step demo.

Preliminary Sketch
You will notice in the preliminary sketch and the finished painting that Jeffrey chose not to copy this reference photo exactly, but he instead made creative choices that turned this picture into a unique painting.

1 LAY IN THE EYE
With a no. 6 sable round, start a fairly abstract approach by laying in one eye and then working outward. Use a mixture of Ultramarine Blue, Ivory Black, Alizarin Crimson and Cadmium Red Light. Beginning painters may find it helpful to use some sort of gridding system to ensure more accurate placement of the features.

2 APPLY THE FLESH TONES
Begin drybrushing in the flesh tones with a no. 6 bristle filbert. Use Cadmium Red Light, Yellow Ochre and Titanium White. Add touches of Cobalt Blue and Olive Green. Try to work off your reference as a spring board. Always keep in mind that there are really no formulas when it comes to mixing colors. Only through trial and error will you arrive at the right color for your paintings. Make corrections and adjustments to edges, values and color notes based on your taste and preferences.

For additional demos, bios, art and more, visit **artistsnetwork.com/oil-painting-with-the-masters**.

77

3 RENDER THE OTHER EYE
Start laying in the other eye. Work with a no. 6 sable round, using a mixture of Ultramarine Blue, Ivory Black, Alizarin Crimson and Cadmium Red Light. It is paramount that you make one eye dominate in a portrait. This can be done by rendering one eye slightly more than the other, or by making the highlight in one eye slightly more intense. These should be very subtle variations.

4 RENDER MORE FEATURES
Work your way to the other features as well as the hair. Keep in mind that you want this to be a very fresh effort, so don't overwork it. Using a no. 6 or no. 8 filbert bristle, mass in the dark tones of the hair with a mixture of Ultramarine Blue and Ivory Black. For the warm tones in the hair use Transparent Oxide Red, Cadmium Yellow, Ivory Black and Titanium White. For the flesh tones, use Cadmium Red Light, Yellow Ochre and Titanium White. Add touches of Cadmium Yellow Light to the lighter areas of the face.

5 BEGIN WORK ON THE HAND

Come in from the background to create a silhouette shape for the hand. Again, this is a very complex style of placement. It is a really fun way to work but can be a bit of a train wreck if you lose your placement. Use a no. 8 flat or filbert bristle for this step, working with various mixtures of Ivory Black, Ultramarine Blue, Transparent Oxide Red and Transparent Maroon in order to create variety in the background.

6 REFINE THE EYES WITH ABSTRACT COLOR NOTES

With a no. 6 filbert bristle, paint small abstract color notes around the eye socket with small hints of Olive Green grayed down with a touch of Ivory Black. This is not in the reference photo and was invented to create a more spontaneous look. Pushing color is an art of its own and is fun, but tread lightly.

For additional demos, bios, art and more, visit **artistsnetwork.com/oil-painting-with-the-masters**.

79

7 PAINT THE HAND

Using a no. 6 or no. 8 bristle filbert, lay in the hand using the colors you mixed for the flesh tones, and the painting is covered. Keep the drapery loose and spontaneous like the rest of the painting as you apply Cobalt Blue and Titanium White to the shirt. Do a fair amount of palette knife work here to create a sort of visual noise.

To learn more about Jeffrey R. Watts, his art, Watts Atelier of the Arts and more, visit:

- JEFFREYRWATTS.COM
- WATTSATELIER.COM
- ARTISTSNETWORK.COM/OIL-PAINTING-WITH-THE-MASTERS

8 REFINE AND ADD FINAL DETAILS TO FINISH

Finish painting the shirt. Add final details and make refinements to the rest of the painting as you desire.

Self Portrait
Jeffrey R. Watts
Oil on gessoed panel
14" × 18" (36cm × 46cm)

For additional demos, bios, art and more, visit artistsnetwork.com/oil-painting-with-the-masters.

81

7 BRUSHWORK
with Kevin Macpherson

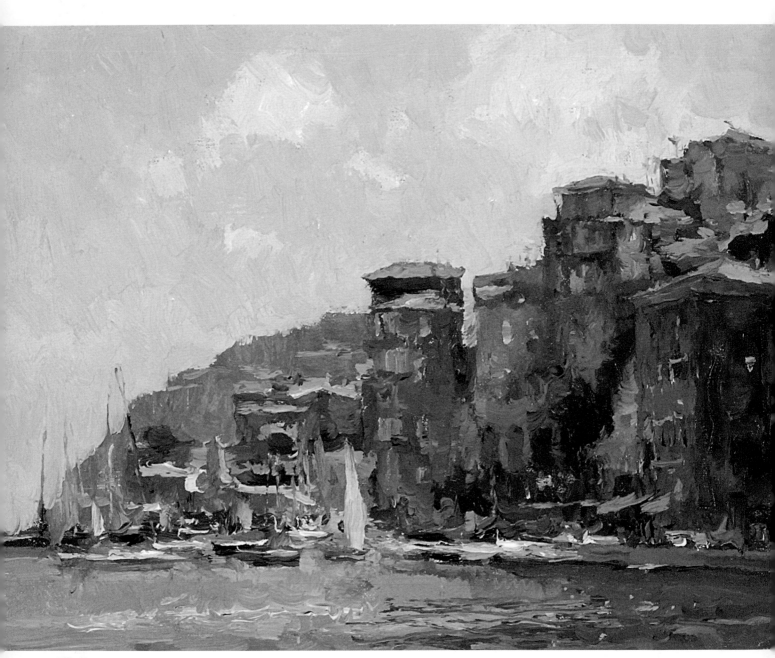

Ville France
Kevin Macpherson
Oil on linen mounted to panel,
11" × 14" (28cm × 36cm)

" **ART IS NOT WAT YOU SEE,**
but what you make others see."

— EDGAR DEGAS

ABOUT **KEVIN MACPHERSON**

Art has always been at the center of Kevin Macpherson's life. Even at the tender age of seven, he knew he would become a professional artist. His earliest childhood memories are of drawing directly on his grandfather's porcelain kitchen table. He enjoyed drawing with his grandfather, who gave him lessons on how to sketch animals like rabbits and turtles. "And being able to wipe the pencil marks right off without ruining the table or getting into trouble was a big plus!"

Kevin majored in illustration at Northern Arizona University and feels he was very fortunate to have Chris Magadini as his instructor. "Magadini was inspiring and encouraged the best from his students. He became my first mentor, and we've remained friends and painting peers to this day."

After completing his formal art education, Kevin spent eight years as a freelance illustrator in the advertising field. To improve his illustration skills, he continued his studies by taking fine art workshops at the Scottsdale Artists' School. The path to improve his illustration skills changed Kevin's life in a big way. "It was during those workshops that my eyes were opened to the world of painting on location."

Countless hours outside directly observing nature taught Kevin how to truly see as an artist. This immediately influenced his illustration work, but more importantly it set fire to his passion for painting from life, en plein air.

"Since then I've traveled throughout most of the world. New places and faces have inspired my work, my entire career, and it keeps me curious. Every day feels like a vacation. While on vacation our senses are at their highest level. And an artist needs to be sensitive. For the plein air artist, travel is the perfect companion."

Kevin and his wife, Wanda, live high in the mountains east of Taos, New Mexico. However, he spends months at a time away from home, painting every day, visiting museums and experiencing the lifestyle of many different cultures. "Art is a universal language that opens up many doors every place I go. What inspires me the most are nature's infinite arrangements of color, light and atmospheric effects."

"An artist must go with inspiration wherever that may lead. It takes years to master skills necessary to communicate inspiring works of art, but it may be dangerous to become too comfortable repeating past successes. You may produce a satisfactory product but it is not satisfying to repeat formulas. We work so hard to figure out how to do it but when we reach

Kevin Macpherson

that place of knowing, most artists I admire will raise the bar and find new challenges."

Recent travels to Asia have shifted some of Kevin's gears. "I went there as a landscape painter but was so inspired by the people of China that I began painting portraits and figurative works. I find these subjects to be very challenging."

One of the country's leading plein air painters, Kevin is highly respected among collectors and fellow artists alike. Past president of the Plein Air Painters of America, he is a popular instructor, guest lecturer and art juror throughout the United States and abroad. His painting workshops are highly attended, often selling out years in advance.

Kevin is represented by The Redfern Gallery in Laguna Beach, California, and Studio Escondido in Taos, New Mexico. He has won numerous national awards, including so many in the National Oil Painters of America competitions that he was the first artist in the organization to be elevated from Signature Member status to that of Master Signature Member.

For additional demos, bios, art and more, visit artistsnetwork.com/oil-painting-with-the-masters.

83

ON **BRUSHWORK**

Impasto is an Italian word, meaning thickly applied. It is the process or technique of laying paint onto a surface quite thickly, so that it stands out. Thick paint looks confident. It delights the eye and can help direct attention to the focal area.

Brushstrokes often reveal the intent of the artist. Each stroke reflects a decision. Will you use long strokes or short? Transparent or opaque pigment? Will you apply the pigment wet-into-wet, in dabs, or scumbled over dry? There are so many options with oil paints.

Develop a good habit early on by forcing yourself to squeeze large puddles of pigment onto your palette. One of the most common mistakes beginners make is being stingy with their pigment out of fear it will be wasted if mistakes are made. However, oil paint can be scraped off, as well as rearranged by negative sculptural manipulation. So don't be afraid to trowel the paint on heavy—like icing on a cake. (You may even want to put your finger into it.)

Variety is also very important in brushwork. If all of your brushstrokes are similar, there may be unity but the painting will also verge on being monotonous. So mix it up. Just take care not to over blend or beat down a fresh brush mark, as you may lose all evidence of your intent.

Different types of brushes will create different effects. Each brush type has something unique to add to the vitality of a painting.

- **Hog bristle rounds** have the most liberating style, as they offer a wide variety to the strokes, making them appear more organic, swirling and calligraphic. The pressure applied greatly alters the character of the stroke.

- **Sable or badger hair rounds** offer a similar feeling, but due to their softness, create a more handwritten, linear effect. These are great for drawing initial placements and painting smaller detailed areas in the finishing stages.

- **Hog bristle filberts** are a great go-to brush, offering a blend of qualities found in rounds, flats and brights. Their slightly rounded corners soften the transits from one stroke to the next. Similar to brights, filberts can really shovel paint and spoon it on, but they don't leave the obvious chiseled stokes like brights may. A ½" (13mm) no. 8 filbert is a good all-around brush for manipulating small shapes. Press hard to create larger strokes.

- **Sable or badger hair filberts** sized ¼"–½" (3mm–12mm) work well for modeling forms and faces that need more detail.

- **Brights and flats** are square shaped brushes, flats having longer bristles than brights. Brights are shovel brushes, best for laying on opaque pieces of paint with direct strokes. The overuse of brights can create a monotonous pattern of similar-sized strokes, unlike the other brushes that make more organic shapes. However, these can be very handy when explaining planes and adding texture. After extended use, the corners wear down, and they become similar to a filbert.

- **Flat and bright soft sables** are useful for shoveling on the paint, too, but add even more variety to the strokes with varied pressure. They also work well for tickling the borders of shapes for soft edges with a light flickering back-and-forth touch.

Brushwork reflects your voice as an artist. Alter your inflection with brushwork just as you do with your speaking voice. Let your enthusiasm for the subject direct the brush, and constantly keep in mind what you want to convey.

En Plein Air

The nature of plein air painting forces an artist to paint at a speed that for many is very uncomfortable. Kevin thrives on this anxiety state-of-mind. His skills are in tune, but secondary to his intuition. This reactive performance state can sometimes breed failures. However, the combination of this process along with years of studying the foundational skills necessary for the impassioned race against the fleeting effects of nature often brings unexpected highlights beyond expectations. The best experience is when the artist finds himself in "the zone," watching the painting evolve magically, almost like an out-of-body experience.

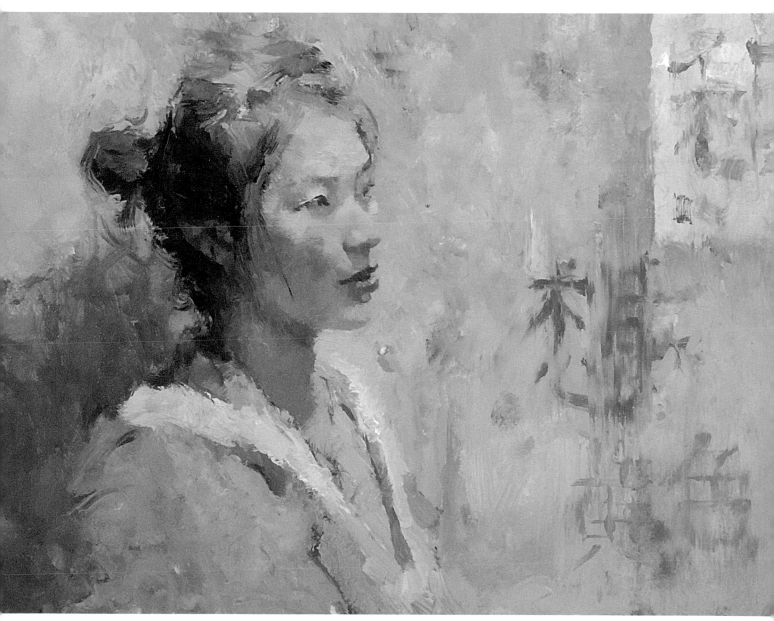

Surface Affects Brush Effects

Brushes respond differently on gesso board than they do on a canvas. Gesso is a bit more absorbent or, at times, can be slicker than canvas depending on the number of coats and sanding of the surface. Each support has its own qualities that affect the brushwork. Mixing up your surfaces allows you to experiment and discover new attributes of your brushes. In this painting, soft edges prevail, adding the expression of harmony. Kevin avoided using hog bristle brushes with this piece, as he did not want the chiseled strokes to be seen. He was able to achieve a more organic brushwork with sable flats and brights.

Harmony
Kevin Macpherson
Oil on gessoed board,
18"× 24" (46cm × 61cm)

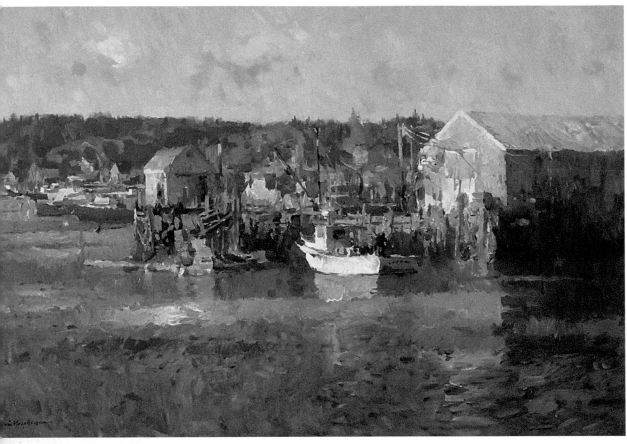

Down East
Kevin Macpherson
Oil on stretched linen canvas
24"× 36" (61cm × 91cm)

Impressionistic Strokes Create Large Masses

Kevin began this painting with a simple gray underpainting using large bristle flats. While still wet, he mixed color right into the gray underpainting with nos. 8 and 10 hog bristle brushes. Many of the strokes in this painting are small impressionistic dabs used to create the big masses.

Cold Air Affects Paint Methods

This piece was done on a sunny yet chilly day. Paint has a tendency to stiffen in the cold, so using stiff hog bristle brights and filberts is more effective than using softer sables. In cold weather, the sable cannot scoop up the paint as well as a stiff bristle can. Painting quickly outdoors and being forced to grab a lot of paint in order to move it in the cooler weather adds to the impasto alla prima technique.

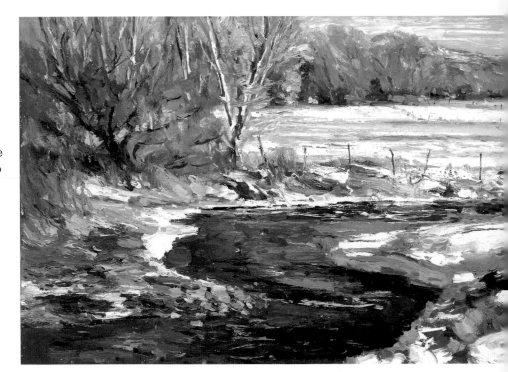

Winter Break
Kevin Macpherson
Oil on acrylic cotton mounted to RayMar panel,
18" × 24" (46cm × 61cm)

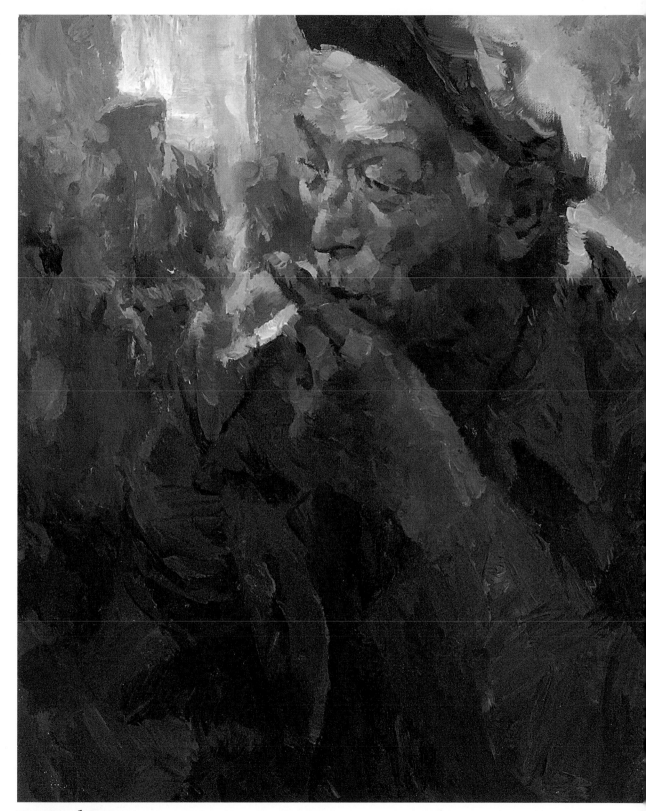

A Good Smoke
Kevin Macpherson
Oil on linen mounted
to RayMar panel,
20" × 16"
(51cm × 41cm)

Vary Brush Type
This painting uses soft sables and rounds with very calligraphic effects before progressing to filbert hog bristles and then back to sable flats. The painting was finished by manipulating shapes while maintaining a direct, yet softer overall quality.

For additional demos, bios, art and more, visit **artistsnetwork.com/oil-painting-with-the-masters**.

87

Create a Dynamic Landscape Painting
WITH BOLD BRUSHSTROKES

The start of any painting is the most enjoyable part of the process for Kevin. He often starts with a flat no. 10 bristle and freely draws through the main masses and rhythm of the painting. Sometimes he lays the canvas on the floor and stands above it as he warms up with the general sweeping movements of the painting. This mentally prepares him for what's to come without any commitment. He then takes mineral spirits and a rag and wipes it all together to create the undertone. This is just a warm-up procedure to get the tone on the canvas and give him an idea as to where he is headed.

Kevin tried to use the largest brush possible for the task at hand throughout the painting—the no. 10 was his main tool for much of the process. The longer he has his tool in his hand, the more familiar he becomes with it, using it as an extension of his thought process and hand. When he shifts to a different brush, he needs time to warm up to it. So for Kevin, manipulating one brush in many ways allows him to think big.

Follow the steps to create a landscape using bold brushstrokes.

Materials

SURFACE

Claessens double-primed linen #15

BRUSHES

½" (13mm) and nos. 6, 8 and 10 hog hair flats, bristles and filberts

½" (13mm) sable flat

PIGMENTS

Cadmium Red Light, Cadmium Yellow Light, Portland Gray Deep, Portland Gray Light, Portland Gray Medium, Titanium White

OTHER

odorless mineral spirits

paint thinner

rag

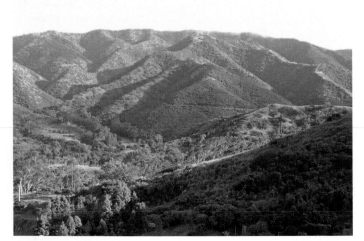

Reference Photo

Value Sketch

Use a black marker to create your pattern of light and shade. This will separate the light family from the shadow family so their relationships can be clearly seen.

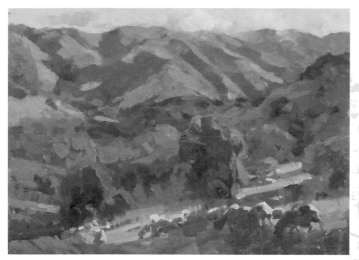

Study

Kevin completes many small studies on a painting trip. A painting done on the spot will often have a freshness and spontaneity. The struggle and shorthand of the plein air art adds to the charm.

Many of these small studies could be successful paintings in their own right; however, due to the movement of animals or the changing light, many remain studies.

"If I capture some truthful color notes and realistic gestures in fresh brushstrokes, I see it as a successful mission," Kevin says. "I bring home a lot of fuel for large paintings. I keep my camera handy snapping hundreds of pictures. My plein air color studies and my photographs offer necessary information for more thoughtful arrangements in the studio."

The Big Picture

Always remember to create the big picture first. These are the biggest simplified shapes, the most important representations of light and shadow. Keep in mind that each major shape must be properly related. If these relationships are not established, then all the detail and modeling you do will be incorrect and a waste of time.

Start with the lightest light and the darkest dark. These two notes of color and value will set the high and low parameters to guide all other comparisons. Shadow colors relate to the dark note. Sunlight colors relate to the light note.

Use this simple method to infuse light and color into your paintings. Each day, each moment will have different combinations and different relationships of values and color. Observe directly and very carefully to find these relationships to make each painting unique.

When all colors and values are related properly and all shapes and proportions are properly placed, then the painting is nearly complete. At the point where no more corrections need to be made, put your brush down. You are finished.

1 TONE THE CANVAS

Starting a painting can be intimidating. It is sort of like golfing at the first tee with a large audience watching your first stroke. Get up there and swing away and get the ball rolling. Think of the potential. This blank canvas may be your masterpiece.

Splash odorless mineral spirits onto the canvas. Use a rag to smear Portland Gray Light over the entire surface to tone down the white of the canvas. Rub it into the canvas weave. This light gray tone will read as "white" once you get further into the painting process, and may save you from running out of value on the light end.

For additional demos, bios, art and more, visit **artistsnetwork.com/oil-painting-with-the-masters**.

89

2 CREATE A SIMPLE SHADOW PATTERN

Use a no. 10 flat to lay in the shadow areas in a simple pattern with Portland Gray Deep. Thin the pigment with odorless mineral spirits. Use just enough solvent to help the brush move across the canvas. Start with the biggest and simplest representation. Defining the shadow family will place the light family automatically. Connect the dark and light shapes. Make adjustments to the arrangement as you see fit. Do not feel obligated to merely copy your reference material exactly as it is.

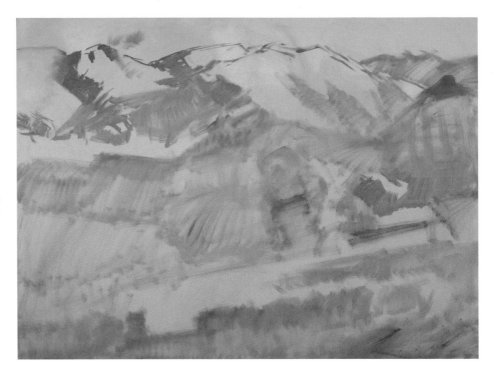

3 DEFINE AND LINK LIGHTS AND DARKS

Reduce the chaos of nature into two shapes; the sunlight family and the shadow family. Separate the two families, and link them together for a powerful, simplified statement. This value plan will provide the host values for the upcoming color.

Continue using a no. 10 flat and gray tones. Begin to add darker shapes within the shadow family. Both families have a range of values. At this point, do not go into the light family. Keep the representation of the light only in that initial Portland Gray Light wash you did in the first step. Find visual movement throughout the picture with dark accents that attract attention. Even a dark shape deep into the hills effectively draws the eye. Don't be afraid to add a dark in the far distance.

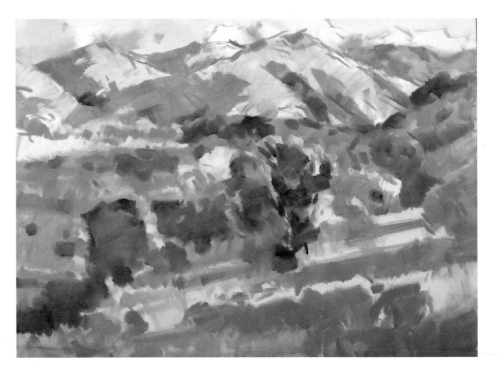

4 PAINT THE LARGE, FLAT ABSTRACT SHAPES

Continue using a no. 10 flat to paint the large flat masses of value. Avoid color at this stage. Concentrate on designing attractive shapes and relating the value throughout the picture.

Paint the flock of sheep as a linked unit with a no. 8 filbert. The simplified light shapes and shadow silhouettes suggest multiple animals. Characteristic silhouettes make objects recognizable. Detail does not enhance as much as an expressive silhouette of each shape will. Pay attention to each contour. Use negative shapes to describe an object effectively. Let the ground shadow describe the sunlight on the backs of the sheep. Focus on shapes, not things. This painting is a mosaic of interlocking shapes.

Paint the light side of the distant mountains with Portland Gray Medium. This value will be the general dark end of the light family. Don't use solvent. The gray is a relatively neutral color... until a color is placed adjacent to it. Once the scheme is colorized, the gray will take on either a cool or warm temperature.

5 ADD COLOR

Painting a large canvas can take many days. Dividing the tasks of drawing, composition, value and color is a convenient and effective method. While this painting was done wet-into-wet, you can stop at any stage and even let the gray foundation dry, if necessary. Surprisingly, applying color right into the gray will not muddy the pigment.

Mix Titanium White, Cadmium Yellow Light, Cadmium Red Light and a small amount of Portland Gray Light into the wet gray foundation to create shadow tones in the mountain area. If a little gray peeks through, it will add to the color vibration, creating warm and cool titillations. Mix your color right on the canvas itself with a no. 8 hog hair flat and a no. 8 filbert bristle, using the gray as a starting point.

For additional demos, bios, art and more, visit **artistsnetwork.com/oil-painting-with-the-masters**.

91

6 BEGIN THE SKY AND GROUND PLANES

Indicate the color of the sky with opaque Portland Gray Light using the no. 8 hog hair flat and no. 8 filbert bristle. The color will appear darker in value than the diluted gray tone that was initially applied to the blank white canvas. Continue to use Portland Gray Light opaquely for the ground planes in sunlight. Leave the lighter original tone for the clouds and the light sides of the sheep. These areas will reveal the lightest light notes.

7 ADD MORE COLOR

Add a touch of Titanium White to the same mixture you used for the mountain shadow tones and use that to paint the cloud shadows with a no. 6 filbert and flat hog hair bristles. This will add harmony as it repeats a color that unifies different areas of the painting.

Infuse skies with the warmth and colors of the earth. Find a way to tie all the colors within the scene together as if every object is having a dialogue with each of the other objects. Color proportion is very important. Have one color dominate. Save the purer notes to add spark. Too much bright color will only appear to scream out, "See me!" Keep the light and shadow shapes of the clouds separated. The cloud silhouettes should have a soft contour as they meet the "blue" of the sky, but don't allow them to lose their shapes with over-modeling.

Soften the cloud edges using a ½" (13mm) flat sable. Go back and forth across the shapes quickly. Let the brush pick up some of the cloud or sky color and drag it in the adjacent shape, but take care not to over soften. The values of these two shapes are close, so a hard-edged shape will still appear relatively soft-edged with low contrast.

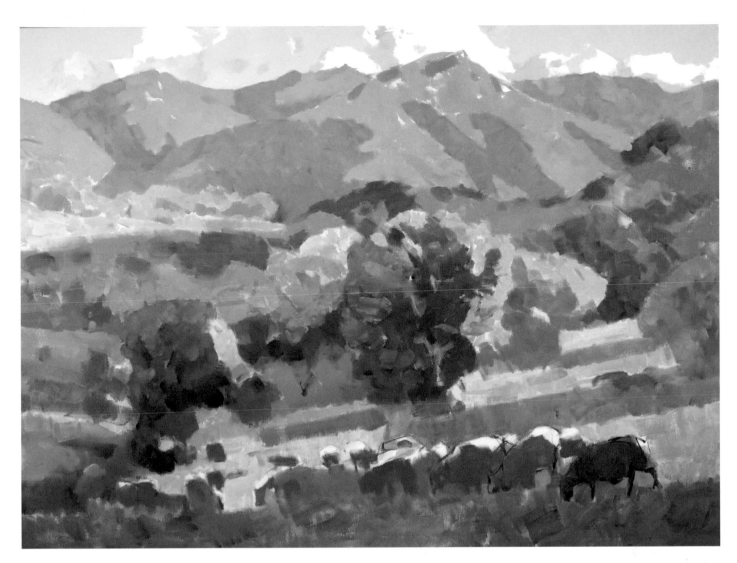

8 REFINE THE PAINTING

To add atmosphere, use some of the cloud-shadow mixture to lighten and adjust the shadows of the distant mountains. Be careful not to overdo this, or you may lose the value contrast completely. You'll also need to lighten the light side of the mountains until the relationship feels correct. The values are so close, it really is about warm and cool color contrast as much as value contrast.

Tickle the cloud edges carefully with a ½" (13mm) hog hair bristle flat. Manipulate the edges with ease while both the cloud colors and the sky colors are still wet. The warmer cloud colors will cause the gray of the sky to appear blue.

Along the border where mountaintop meets sky, tickle the edges using up-and-down and side-to-side strokes. Think variety—hard and soft edges.

Keep color clean and rich. However, sometimes too clean and too much brightness nullifies the color. We need neutrals to balance and actually intensify the intended rich and more colorful areas. A good painting has unity and variety, harmony and contrast. Harmony is similarity and repetition. Too much of this is boring. Variety is the spark, discord and contrast. Too much of this and we have chaos.

For additional demos, bios, art and more, visit **artistsnetwork.com/oil-painting-with-the-masters**.

93

9 ADD COLOR ACCENTS

Shadows are not colorless and dark. We can see into shadows because of the reflected light. Add some small bright color notes in shadow areas around the canvas as desired. This will help spark the scene's interest.

Don't be afraid of going too bold with your color. Remember that anything can be changed or subdued. An intense warm note can recede into the distance as it relates to other passages. Defy the rule that color needs to be cooler in the distance.

Overlapping and size relationships within the canvas will fool the eye into believing something very warm can live deeper in space. For instance, a small pure orange note will recede because the viewer compares it to the large orange tree in the foreground.

Tickle the edges with a ½" (13mm) soft sable flat, mostly dry with no paint to soften the transition between the sky and mountain edges. The paint in both the mountain and sky is wet, so you can subtly move it back and forth to create both lost and found edges along this border. If the brush becomes dirty with color, rinse it off in mineral spirits. Dry it off with a rag or tissues so it is dry for the tickling. Because the tree is a value contrast to these two shapes, the edges can be quite soft but still maintain the integrity of contrasting value.

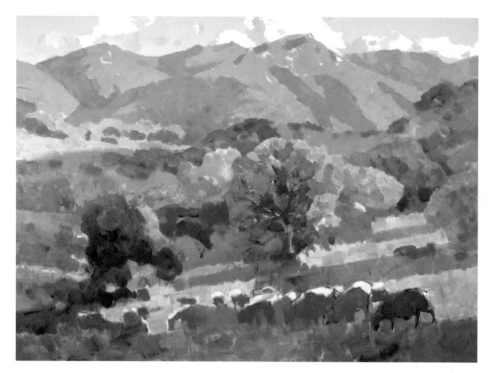

10 EVALUATE AND MAKE ADJUSTMENTS

Step away from the canvas and go back later to look with a fresh eye. Rotate the canvas for an objective evaluation. Look top to bottom, side to side. A picture should feel balanced. Are there areas that demand undue attention or any relationships that seem out of place? Distribute colors, shapes, spaces, values, and accents asymmetrically, but balanced. Paint upside down to check for repetition of shapes and see areas fresh that demand attention. Use contrast and the sparks of your pure color to guide the viewer through your painting. You do not have to have one focus spot that overwhelms the viewer. To keep them engaged in the painting, create a path in, through, and around to the focal point and back again.

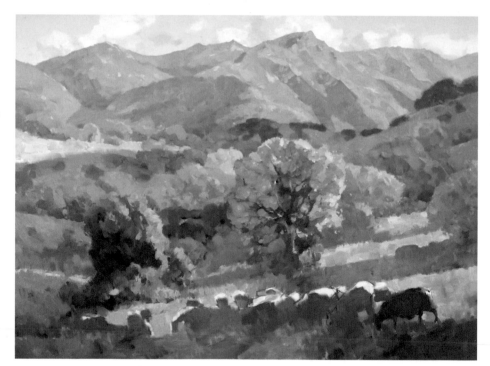

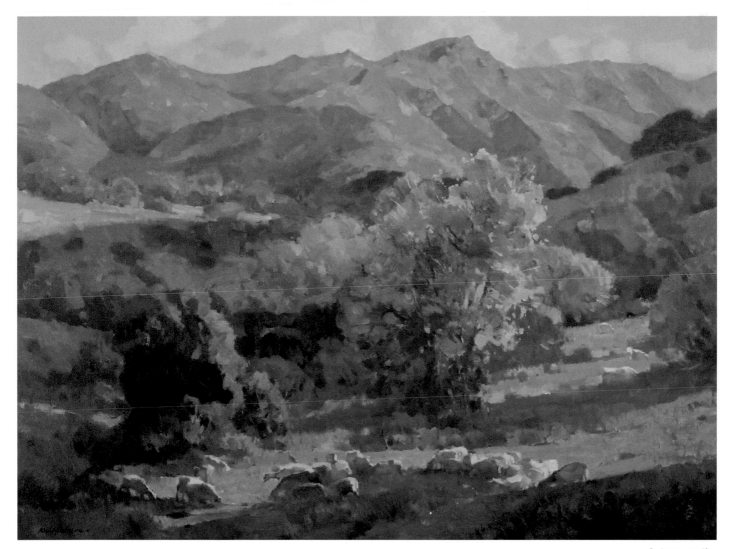

11 FINISH WITH DETAILS

The center tree seems too centered, so raise it up to cross over and fully engage the distant mountain. Add a lacy silhouette to the right to bring more interest to the composition.

Make the arrangement of the sheep more interesting. The lighter notes within the sheep mass should move the eye through and offer pause to areas. Descriptive silhouettes will slow the eye, and bright notes will direct the viewer. Notice the reduced scale of the animals. The eye will naturally follow left from the position of the sheep, so stop the eye and redirect the viewer back into the picture by reversing the direction of the sheep on the left.

Much of the work in this stage adds interest in the light family ground planes. Suggest color changes and redesign the size relationships of the different sun and shadow shapes on the ground. Add variety and undulation to the landmass with different angles, curves and horizontals.

Review each area of the painting and make subtle changes adjusting the hard edges or values of colors that called out too much attention. Add warmth to the shadowed large green pastures on middle left. Heighten the sun-shadow relationship with a vibrant cool blue edge just before the shade goes into the light. Scumble drybrush color over the distant autumn trees to soften edges.

Autumn on the South Island
Kevin Macpherson
Oil on double-primed
linen, 30" × 40"
(76cm × 102cm)

To learn more about Kevin Macpherson, his art, Passport & Palette television and more, visit:

∾ **KEVINMACPHERSON.COM**

∾ **ARTISTSNETWORK.COM/OIL-PAINTING-WITH-THE-MASTERS**

THE FOCAL AREA
with Robert Johnson

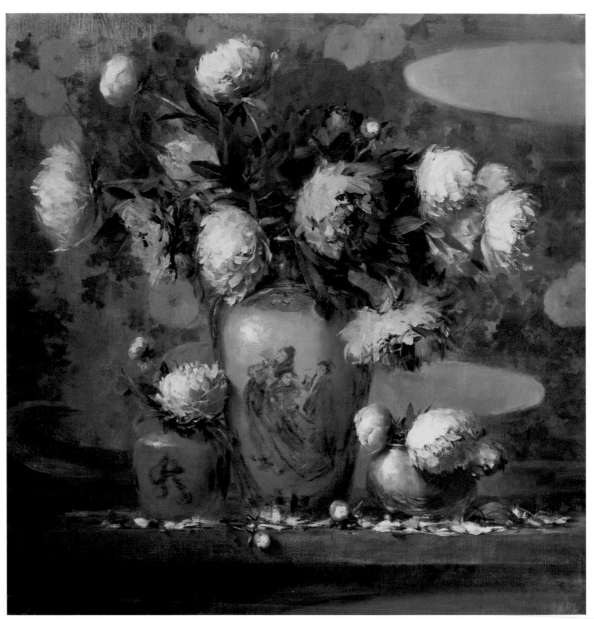

Gifts from Asia
Robert Johnson
Oil on double-primed
oil portrait weave
linen canvas,
32" × 28"
(81cm× 71cm)

"DO NOT COPY NATURE TOO MUCH.
Art is an abstraction."

—PAUL GAUGUIN

ABOUT **ROBERT JOHNSON**

Since he first observed a skillful artist create the illusion of form, space and a feeling of the real world with only a brush and paint, Robert Johnson has been captivated by the magic of the painting process. "To me it has been an incessant challenge to capture this magic in my own work. To attempt to communicate that immediate emotion and powerful visual experience succinctly is what keeps me going back to the easel. Each time, I feel the same fascination and excitement that I experienced watching the painting process for the first time as a boy."

Robert grew up in the small town of Hopewell, Virginia, with a family who shared and supported his passion for art. Although his family and teachers recognized his artistic talent, art was not considered a realistic or practical career path in Robert's world at that point in time. He focused instead on academics and sports, went on to attend Duke University on a football scholarship and later, graduated from Duke Law School.

He began a career in law while cultivating his artistic skills in the early mornings, evenings and weekends, attending classes in anatomy and drawing at local universities. The conflict between his law career and his artistic passion continued to mount, however. After seeking advice from Frank Wright, an art professor at George Washington University, Robert turned over his law practice to his partner and devoted himself to art full time.

Throughout this time, his brother Ben (who was an accomplished artist in his own right and served as the Director of Art Conservation for the Los Angeles County Museum) was a constant advisor and constructive critic. He regards his late brother as a knowledgeable and generous mentor to whom he attributes much of his artistic progress. He encouraged Robert to continue his artistic education and to compare his work only to the work of the masters.

With this advice in mind, Robert enrolled at the Art Students League of New York, where he studied painting with David Leffel and drawing with Robert Beverly Hale, Michael Burban and Gustav Rehberger. He later went on to teach at the Art Students League and remains a life member.

Robert continued his training in the studio of Hungarian-American master Lajos Markos, whose descriptive brushwork and understanding of form and gesture continue to influence his work today.

Robert Johnson

His awards include first place national juried awards from *The Artist's Magazine* and Salmagundi Club of New York. Five of his paintings won awards from Oil Painters of America, including one which received the *American Art Collector* magazine Award of Excellence. He has had twenty one-man gallery shows and has produced seven instructional videos.

Robert currently teaches painting workshops throughout the United States and Canada. He is the author of *On Becoming a Painter* (Sunflower Press, 2001), in which he describes his thoughts on developing an understanding of the fundamentals of the painting process. His work has also been featured in *The Best of Flower Painting* II (North Light Books, 1999) and *The Simple Secret to Better Painting* (North Light Books, 2003).

Robert's work is represented in several private galleries, including the Sage Creek Gallery in Santa Fe, New Mexico, and Trailside Galleries in Scottsdale, Arizona, and Jackson Hole, Wyoming.

He lives in Vienna, Virginia, with his wife, Virginia, and their daughter, Lisa.

For additional demos, bios, art and more, visit **artistsnetwork.com/oil-painting-with-the-masters**.

97

ON THE IMPORTANCE OF THE FOCAL AREA

The focal area is the organizing principle of the painting that guides a painter from the first compositional design strokes to the final application of paint. It is what a painting is truly about.

A painting without a focal area is like a novel without a main character. Although paintings are purely visual forms of art, they still require the organization, structure and purpose that go into a well-comprised novel. In a painting, that organization, structure and purpose all come from the focal area.

Your task as a painter is first to create a compelling design on the canvas by arranging the large shapes and values so the painting will carry from a distance and capture the viewer's attention. Once the viewer is drawn to the canvas, they must be able to see and understand the visual and emotional statement the artist has made.

The focal area is the primary tool for organizing the canvas and making a statement powerful and visually captivating. The viewer's eye should journey around the canvas, stimulated by strong colors, skillful draftsmanship and bold value relationships. This visual journey is organized to lead the eye on a well-paced path to the focal area.

The function of the focal area is to then arrest the visual journey and rivet the viewer's attention on a well-resolved passage before continuing the visual journey to other parts of the canvas. It is because of this important function that the focal area must be visually compelling, well rendered and strategically located in an aesthetically functional portion of the canvas.

Once the idea and placement of the focal area is clearly resolved in your mind, all the other decisions regarding placement of visual events and their relative strength or weakness can be related to their relationship with the focal area. Let that original idea guide you through the rest of the decisions you will need to make during the painting process. With a clear idea of what the focal area will be, the task of completing the painting will move more quickly.

Decisions on color, value, edges, and paint quality all have something to relate to and guide your choices. Painting will become more and more of a joy as your instincts begin to replace your intellect. As your hesitancy diminishes, your paintings will begin to flow more naturally and gracefully.

Looking Back

Robert Johnson's most memorable painting experience was when he was painting at the Art Student's League of New York. "I was studying with David Leffel in a studio that had beautiful constant north light at all times of the year and a rich tradition of distinguished instructors. In the class was an elderly man with whom I had enjoyed numerous chats during breaks in the class. He was a gentle soul in his nineties who wanted to learn how to paint. When I saw the energy and enthusiasm with which he was attacking his canvas, I decided to paint him instead of the set-ups and models for the class.

"I'll never forget that studio with its beautiful light and rich artistic tradition, my friend in his nineties with the process of art bringing out in him the energy and enthusiasm of a teenager, the emotion of the moment, and the challenge to try to capture it with paint."

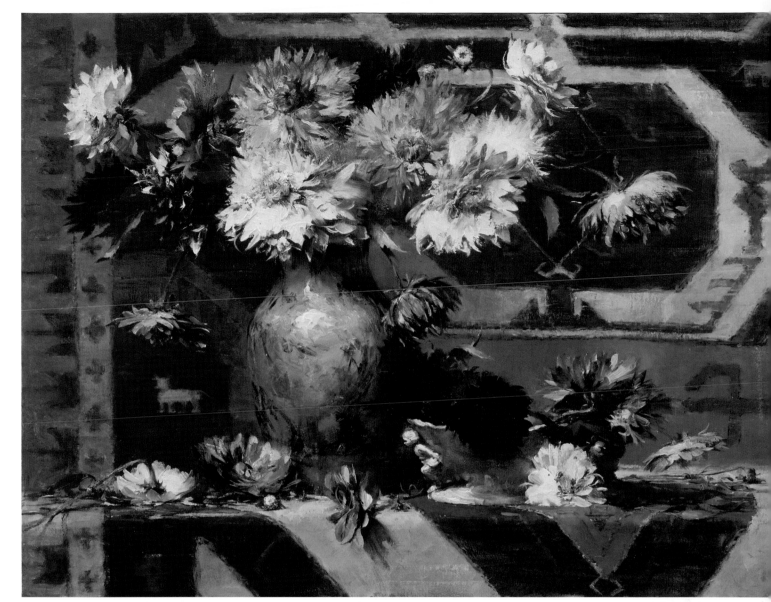

Edges, Contrast and Activity Help Draw Attention to the Focal Area

The focal area of this painting is the large white dahlia as it exits from the mouth of the blue vase. Hard edges, high contrast in values, and busy visual activity were all used to capture and hold the viewer's attention. At the lower right of the focal area, the upward gesture and visual projection of the cupid figure helps to carry the viewer's eye up towards the focal area. The vertical emphasis of the petal arrangement of the flower to the lower left of the white dahlia also subtly projects the viewer's attention to the focal area.

Dahlias in a Chinese Vase
Robert Johnson
Oil on double-primed oil
portrait weave linen canvas,
26" × 34" (66cm × 86cm)

For additional demos, bios, art and more, visit artistsnetwork.com/oil-painting-with-the-masters.

99

**Silver Pitcher
with Roses**
Robert Johnson
Oil on double-primed
oil portrait weave linen
canvas, 18" × 24"
(46cm × 61cm)

Intensify Darks to Draw Attention to the Focal Area

The focal area is the bright red rose exiting the mouth of the pitcher. Robert used pure, thickly applied Cadmium Red Light for this area. The darks were intensified to establish the high contrast in values necessary to capture and hold the viewer's interest in this area. The greenery and arrangement of the roses to the lower left lead the viewer toward the pitcher and into the focal area. While the greenery to the right of the focal rose leads the viewer off to the right and away from that rose, the arrangement of the stems and leaves as well as the direction of the yellow rose to the right leads the viewer on a stimulating journey with calm moments as well as more active, visually arresting events that ultimately lead back to the pitcher and the focal area.

The Focal Area Holds the Whole Painting Together

The gravitational force that holds this painting together is the clear and accurate depiction of the bridal doll. The face is clear, accurate, honest and painted with fresh light and somewhat impasto paint that contrasts with the relatively thin darker areas around her. This polarity in values can be visually riveting. The flowers to her upper right add a counterpoint and note of festivity and excitement to her existence, but do not compete with her as the focal area of the painting.

Dolls and Roses
Robert Johnson
Oil on double-primed oil portrait weave linen
canvas, 20" × 30" (51cm × 76cm)

Supporting Elements and Fine Details Lend Power to the Focal Area

Clearly the focal area of this painting is the Chinese figure. Where would the painting be without her? The shaft of light from the left lands on her face and brings out her solid character, form and serene expression. She is accorded additional visual power by the eucalyptus leaves that arch above her and define her special visual space with quiet dignity. Even though she is ceramic, the human character that inspired her creation is something that arrests the viewer's attention on her. Robert tried to be faithful to details in depicting her face and gesture—again, something precise with human dimension that can hold a viewer's attention in a focal area.

Eucalyptus and Seckel Pears
Robert Johnson
Oil on double-primed oil portrait weave linen canvas, 36" × 28" (91cm × 71cm)

For additional demos, bios, art and more, visit **artistsnetwork.com/oil-painting-with-the-masters**.

101

Use Juxtaposition of Opposites
TO ENHANCE THE FOCAL AREA OF A PAINTING

This demonstration seeks to create a visually compelling painting by juxtaposing the activity and diversity in shapes and strong colors in the vessels and flowers in the focal area against the relatively serene and quiet background of the Chinese print.

Visually, the juxtaposition of opposites—whether they are shapes, complementary colors, values or other pictorial elements—can enhance the overall visual power of a painting.

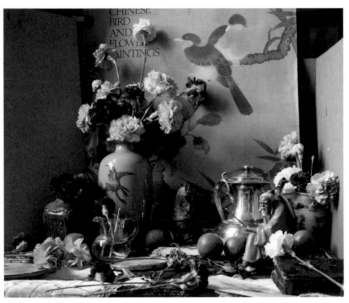

Reference Photo

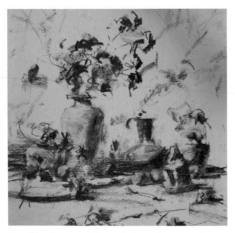

Preliminary Sketch in Charcoal

Materials

SURFACE

portrait-weave double-primed linen on Gatorboard

BRUSHES

2" (51mm) and nos. 2 and 4 mongoose flats

nos. 2, 6 and 8 bristle flats

nos. 4 and 6 bristle filberts

no. 4 sable round

PIGMENTS

Brilliant Pink, Cadmium Orange, Cadmium Red Light, Cadmium Yellow Pale, Cerulean Blue, Cinnabar Green, Cobalt Blue, Cobalt Violet, Indian Yellow, Naples Yellow Light, Permanent Alizarin, Permanent Mauve (Blue Shade), Permanent Rose, Terra Rosa, Transparent Oxide Red, Ultramarine Blue, Viridian, Yellow Ochre Pale, Zinc-Titanium White mixture

OTHER

Gamsol odorless mineral spirits

medium (mix of 5 parts Gamsol, 5 parts stand oil and 1 part Damar varnish)

paper towels

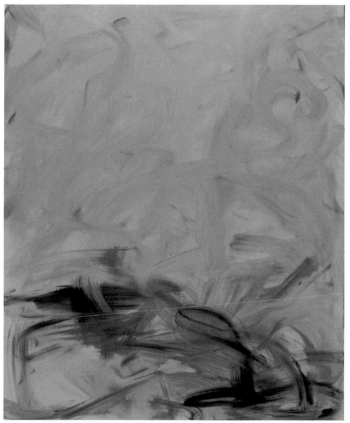

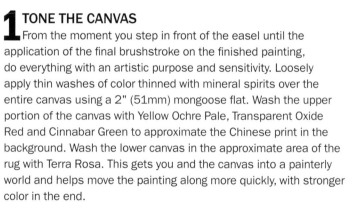

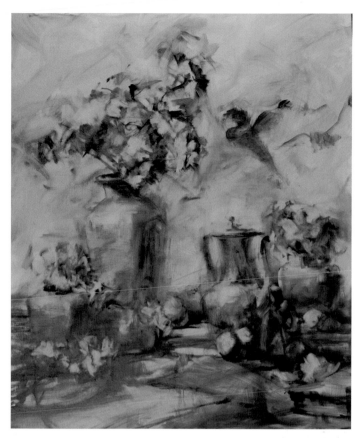

1 TONE THE CANVAS

From the moment you step in front of the easel until the application of the final brushstroke on the finished painting, do everything with an artistic purpose and sensitivity. Loosely apply thin washes of color thinned with mineral spirits over the entire canvas using a 2" (51mm) mongoose flat. Wash the upper portion of the canvas with Yellow Ochre Pale, Transparent Oxide Red and Cinnabar Green to approximate the Chinese print in the background. Wash the lower canvas in the approximate area of the rug with Terra Rosa. This gets you and the canvas into a painterly world and helps move the painting along more quickly, with stronger color in the end.

2 LAY IN THE COMPOSITION

Continue working loosely in a monochromatic color scheme. Use a no. 6 bristle flat with Transparent Oxide Red and Ultramarine Blue to establish the size and placement of the most important visual elements. Make sure the focal area of the carnations is strategically located and properly sized. This will guide your size and placement of all the other objects and visual events.

Use long, loose brushstrokes with the idea that anything you put down at this stage can be changed in order to arrive at a stronger design. You can lift out the lighter areas with a paper towel and mineral spirits, but do so with a descriptive purpose and artistic touch.

Try to fix in your mind and on the canvas which shapes are going to be light and which are going to be dark in the finished painting. Don't leave this stage until you are satisfied that you have a powerful design that excites you about jumping into the work ahead.

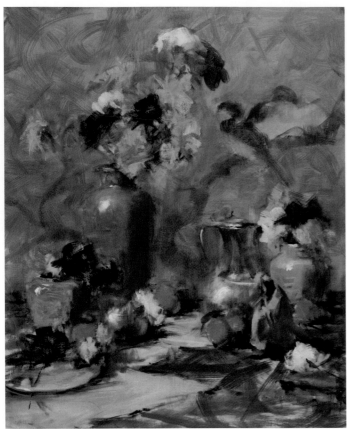

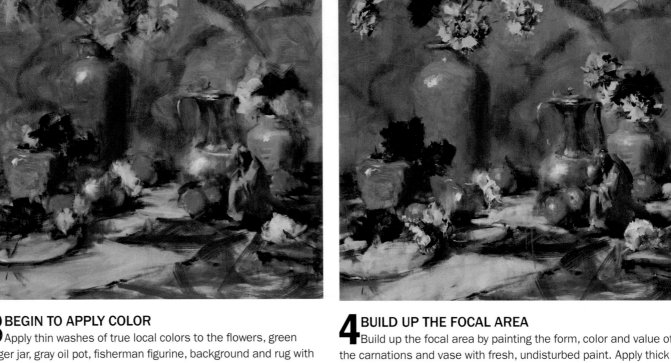

3 BEGIN TO APPLY COLOR

Apply thin washes of true local colors to the flowers, green ginger jar, gray oil pot, fisherman figurine, background and rug with nos. 6 and 8 bristle flats. Use the following colors: Cerulean Blue, Cobalt Blue, Cadmium Orange and white for the large Ching vase; Cadmium Red Light for the red carnations; Cadmium Orange for the tangerines; Naples Yellow for the light carnations; Brilliant Pink, white and Naples Yellow Light for the pink carnations; and Cobalt Blue, Cadmium Orange, Transparent Oxide Red and white for the fishing figure. These will dry quickly and you may be able to use them for middle tones in the finished painting to add a fluid and informal touch. Start applying strategically placed highlights on some of the objects since these will be your lightest lights and will attract and hold the viewer's attention. Everything that follows from this point will have some color relationship with the basic colors being applied in this stage.

4 BUILD UP THE FOCAL AREA

Build up the focal area by painting the form, color and value of the carnations and vase with fresh, undisturbed paint. Apply thick paint to the light areas of the carnations and vase with descriptive brushstrokes. At the same time, add some of the darkest darks in the flowers. The lightest lights and the darkest darks should be roughly established at this point, and all future applications of paint should fall somewhere between these two values.

Use a no. 6 bristle filbert to paint the blue Ching vase with Cerulean Blue and white, predominating in the lights with touches of Naples Yellow Light and Cinnabar Green. As the vase turns to shadow, add Cobalt Blue and Transparent Oxide Red to the Cerulean Blue.

Paint the red carnations with the same brush, using Cadmium Red Light and Permanent Rose in the light areas, and Permanent Rose and Ultramarine Blue in the dark areas. Paint the pink carnations Brilliant Pink and white in the light areas, and Permanent Rose and Ultramarine Blue in the dark areas. For the white carnations, use Naples Yellow Light and a touch of Cadmium Yellow Pale in the light areas and Cobalt Violet, Cinnabar Green and Indian Yellow in the dark areas. The darkest accents should contain some Permanent Mauve.

By painting the focal area with strong colors and bold value contrast, the path is set to lead to a more powerful painting in the end.

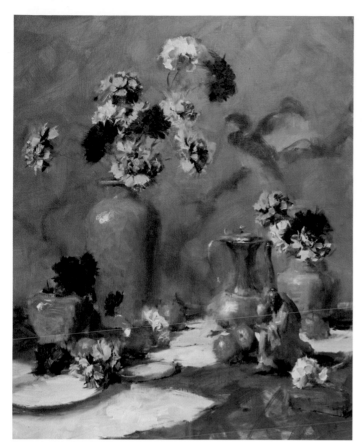

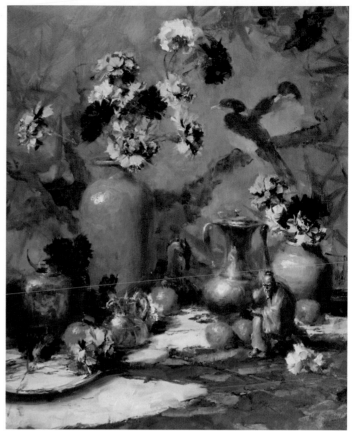

5 ADJUST COLOR, VALUES AND REFINE THE DETAILS

Add more accurate color and values to the rug, plate and needlework cloth as needed. Try to approximate the actual local color and value of the rug, as well as the needlework cloth which represent relatively large masses. Make any needed minor changes that may make for a more appealing design, such as reducing the size of the carnation in the glass pitcher so that the container and flower have a more visually proportionate relationship.

6 BUILD UP THE BACKGROUND

Strengthen the background color and pattern with a no. 6 bristle flat. The base background color is a mixture of Yellow Ochre Pale, Naples Yellow Light and Cinnabar Green, while the background flowers are a subdued version of the focal flowers—Cadmium Red Light with Cinnabar Green and a touch of white.

The foreground and the background must move forward together. With the background color and pattern more finely tuned, you can add more color, patterns and definition to foreground areas such as the rug, the needlework cloths and the plate. Apply the same intensity, temperature and light direction to all of the objects in the painting to give it a convincing and harmonious appearance.

With a no. 4 bristle filbert, paint the Indian horse spice box to the right of the blue vase using Transparent Oxide Red, Cinnabar Green and white. Suggest a cool light on the warm, bright orange tangerines with Cadmium Orange and a whisper of Cobalt Blue and White. Use Terra Rosa, Cinnabar Green and Naples Yellow Light to paint the base color of the rug.

For additional demos, bios, art and more, visit artistsnetwork.com/oil-painting-with-the-masters.

105

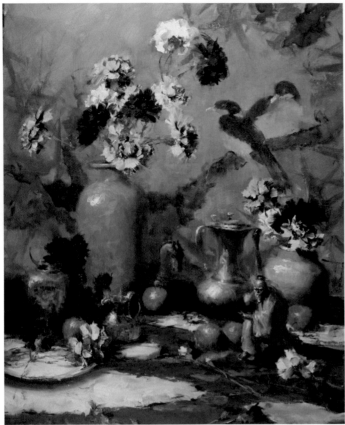

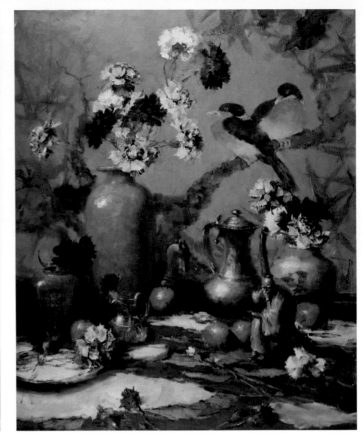

7 BREAK UP STRAIGHT LINES BY ADDING SHAPES

Long straight lines can be visually arresting but artistically boring. Break them up by adding flowers with cast shadows using a nos. 2 and 4 mongoose flats and Permanent Alizarin and Ultramarine Blue with the proportions varied according to the local color of the object or surface the shadow passes over. Move the rectangular light drawing from the mid foreground to a place partially under the red powder box in the lower right of the painting. Break up the resulting harsh line caused by the edge of the drawing with a small carnation and its cast shadow. Remove the white carnation from behind the glass to allow a clearer statement of the glass to evolve without visual competition from the carnation.

8 APPLY FRESH COLOR

Use a no. 4 filbert to apply fresh, clean and accurate color on the green ginger jar, oil pot and silver tea pot. At this stage, each brushstroke should be descriptive and applied with the idea that it will never be changed. For the ginger jar use Viridian and Cinnabar Green. Use Cobalt Blue, Transparent Oxide Red and white for the oil pot. Paint the silver tea pot with Cobalt Blue, Transparent Oxide Red, white and additional pure local colors picked up in the reflective surface.

9 ADD DETAILS AND FINISH WITH REFINEMENTS

Add additional activity, variety and color by finishing the details. Challenge yourself to get the images accurate but not overly detailed, with the idea that the viewer can be involved in completing the images.

Add the spout and handles to the oil pot with a no. 2 bristle filbert. Suggest patterns on the needlework with a no. 4 sable round and Cadmium Orange, Cinnabar Green, Viridian, Cobalt Violet and Brilliant Pink. You can make subtle alterations with white. Paint the geese design on the blue vase with the same brush and Ultramarine Blue with a touch of Cobalt Blue.

Even at this late stage you should be open to design changes that might strengthen the painting. With that in mind, extend the background design into the upper left corner of the painting and

add additional carnations to the mass of flowers in the vase for more power in the focal area.

Finish by making subtle adjustments and refinements throughout the painting, including the glass container, red box, needlework and floral edges. (The fisherman figurine's fishing pole should not be added until after the silver pot is complete.) Use clean fresh paint and a no. 4 sable round.

Some areas of the original transparent wash from step 1 will still be visible in the background and can add a feeling of efficiency and craftsmanship as well as a modulation of color to the finished painting. Note that the strong colors, bold value contrasts, fresh expressive paint quality and accurate draftsmanship originally applied in the focal area has led to more strength and visual power throughout the painting.

ABOUT **PHIL STARKE**

Phil Starke developed an interest in art while living in Europe as a young boy. His father was a military officer stationed in Germany, and during that time, he exposed Phil to the many art museums there, as well as those in Florence and Rome.

Another of Phil's earliest influences was his great uncle, an artist who shared stories about his life-drawing teacher Oscar Berninghaus (a founding member of the Taos Society of Artists). "He introduced me to E. Martin Hennings, Joseph Henry Sharp and Ernest Blumenshien, who were some of the early Taos painters."

Phil would eventually go on to study at the American Academy of Art in Chicago. The instructors at the Academy inspired his passion for oil painting. It was a passion so strong that after graduation, Phil decided to drop his initial plan of working in advertising and instead plunged into a career in fine art. He has been painting professionally ever since.

Although he lives in Tucson, Arizona, he gathers inspiration from painting trips all around the country. Each season and each region has its own unique landscape and color. "I really love the variety I find in nature."

From landscape to figures and plein air to studio painting, Phil continues to find inspiration for his work wherever he goes. "Museums are another source of inspiration for me. It's so interesting to see how other painters observe and respond to the things around them."

"As an artist I'm always learning more about painting, different techniques and ways to see color and render shape and form. I'm always practicing because there is no standing still—you're either moving ahead or going backwards. The art of painting is all about your personal response to your subject, being able to convey to the viewer the beauty of what you see. But the practice of painting is knowledge of the basics and developing good habits of practice and study."

Early on, Phil's interest took him to many parts of the West and Southwest, where he soon grew to love the culture and the landscape. "My goal in painting is to show some of the glory of God in His creation so the viewer can appreciate the beauty of what's around them and see it through the artist's eyes." He feels this is a way of connecting with a busy public—a public that may not take the time to stop and realize the beauty around them. "If I've done my job right, anyone looking at my work will be able to feel the emotion and mood of the moment and will want to spend some time with the piece, taking in all the things I had to say."

Phil Starke

Choosing to share his passion for painting and hoping to inspire others, Phil teaches workshops to help students develop their own individual talent. He also provides online art classes that feature a weekly video lesson and critique.

He believes that practice and perseverance are the most important things needed to achieve artistic success. "Aside from perseverance, seek advice from artists whom you admire, and have perspective on what's most important in your life."

Phil participates in numerous exhibitions and gallery shows. He is represented by the Legacy Gallery in Scottsdale, Arizona; the Grapevine Gallery in Oklahoma City; Settlers West Galleries in Tucson; Ponderosa Art Gallery in Hamilton, Montana, and Whistle Pik Galleries in Fredericksburg, Texas.

For additional demos, bios, art and more, visit **artistsnetwork.com/oil-painting-with-the-masters**.

109

As painters we often become enamored with color—it's the thing that draws us to painting. Color is not as important as value, however. The reason a good charcoal or graphite drawing works with no color at all is because the values within the drawing have the right relationship.

Value Planes

It helps to remember that you are trying to create the illusion of depth while painting on a flat surface. However, a realistic sense of light and form can be created with good value relationships.

In particular when painting a landscape, the composition should be broken down into shapes or planes that catch light at different angles. So if you have four planes in your landscape—the sky plane, the horizontal plane, the slanted plane and the vertical plane—then everything in the landscape will fit into those four planes. Each plane will

catch the light at a different angle to create a different value. John Carlson does a good job of explaining this in his book, *Carlson's Guide to Landscape Painting* (Dover Publications, 1973).

Don't worry about individual objects. Focus instead on the simple planes that create a sense of light throughout the whole composition. If any two planes have the same value, then it will flatten the canvas, causing the form to be lost. For example, if the slanted plane of a hillside is the same value as the horizontal plane of a field, then there will be no sense of depth in the painting.

When you are trying to decide on the value of a plane, don't make the mistake of isolating that plane and just staring at it because you will always misinterpret the value. Instead, look at the plane or value next to it to get the right relationship between the two values. Look and compare in order to achieve the right value.

En Plein Air

Phil's most memorable plein air experience occurred while painting in West Texas. "I was shoved around by a burro, who eventually ate a couple of tubes of my paint. The painting wasn't memorable, but the experience sure was."

It takes him about three hours to paint a small plein air painting in the field. A larger studio piece can take several days, with Phil spending three hours a day painting.

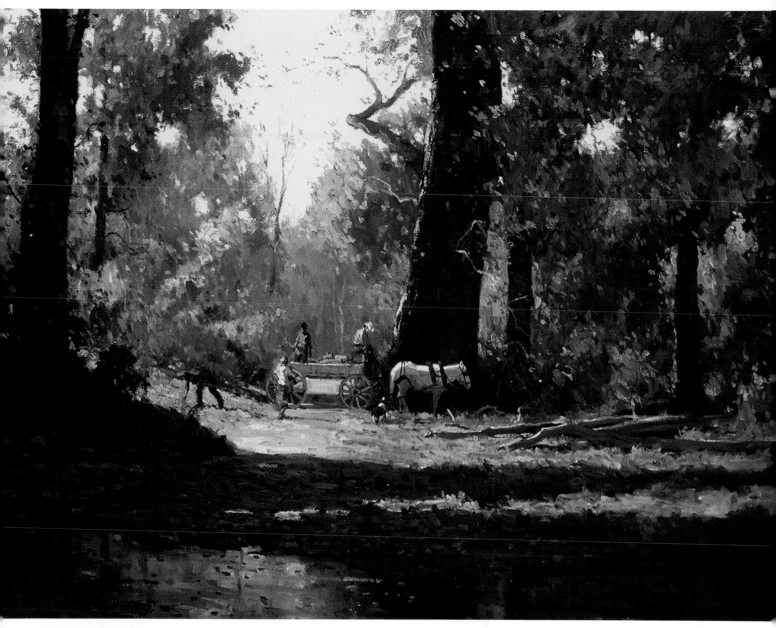

Compare Value Planes to See True Value

There are very strong dark and light contrasts in this painting. Phil had to be careful not to make the darks too dark or the lights too light. He established the darkest darks in the trunks and the slanted plane on the left, but was careful not to use the blackest black or darkest dark possible. This left room to go darker with small accents at the end of the painting.

To see the true value of a plane or object, you have to compare it to another object or plane. For example, in order for Phil to see how dark the large tree trunk was, he had to compare it to the white horse or the yellow foliage to get the true difference between the values. If he had just stared at the trunk without comparing it to something else, he would have painted it too light.

Gathering Wood
Phil Starke
Oil on canvas,
30" × 40" (76cm × 102cm)

For additional demos, bios, art and more, visit **artistsnetwork.com/oil-painting-with-the-masters**.

111

Push the Differences Between Dark and Light Values

If it is a sunny day, Phil will push the value and color temperature differences between the dark and light masses in his composition. On a cloudy day, he will keep it a little more subtle.

Aspen Winter
Phil Starke
Oil on canvas, 30" × 30" (76cm × 76cm)

Balance Foreground Values With Background Values to Achieve the Illusion of Depth

Phil had to get the right relationship between the foreground values and the background values to achieve the illusion of depth on a flat surface. The darks in the foreground have to be darker than the background so that they come forward on the canvas. The lighter the darks are in the background, the more they recede into the distance. The same holds true for the lights—they have to get lighter and cooler in temperature as they recede.

Spring Rain
Phil Starke
Oil on canvas, 24" × 30" (61cm × 76cm)

Compare Dark and Light Planes to Get the Right Values

To create strong value plans you must try and see the landscape in terms of large simple planes of dark and light and get the right value and color temperature relationships between them. It's extremely important to compare one shape or plane with another to get the right value.

Early Winter, Colorado
Phil Starke
Oil on canvas, 24" × 30" (61cm × 76cm)

For additional demos, bios, art and more, visit **artistsnetwork.com/oil-painting-with-the-masters**.

113

Build Value in a Landscape Painting
WITH AN IMPRESSIONIST APPROACH

An impressionistic approach to painting is based more on seeing the landscape in terms of light, atmosphere and brushwork, as opposed to being more detail-oriented like the way a camera records images. Phil's goal in painting landscapes is to use the colors on his palette to give the illusion of depth and form on the canvas, and not try to copy it exactly as it appears. In this regard it helps to have an understanding of how to create depth and the effects of sunlight and shadow, and how to use brushwork to show form. Only then can you try to paint what you see.

In terms of values in this painting demonstration, you will want to see the clear difference in value between the dark trees and the white house. You need to show that contrast to achieve the suggestion of sunlight. Then make sure the difference in value between the sky and the trees are correct, and that the difference between the trees and the flat ground are correct.

Materials

SURFACE
canvas

BRUSHES
nos. 2, 4, 6, and 8 bristle flats or filberts
no. 8 sable round
no. 2 acrylic round

PIGMENTS
Alizarin Crimson, Cadmium Orange Hue, Cadmium Red Light, Cadmium Yellow Light, Indian Red, Titanium White, Ultramarine Blue, Yellow Ochre

OTHER
medium-sized palette knife
paint thinner
paper towels

Reference Photo
Phil photographed this scene for the purposes of this demonstration, but he feels the best way to paint is from life. Photographs are a good tool, but they don't have to be your only source of information.

Preliminary Sketch
The purpose for the preliminary sketch is to work out the composition and decide how to arrange the large shapes. Phil specifically searched for a large shadow pattern that would hold the composition together. He usually uses a 4B or 6B graphite pencil and sketch pad for his preliminary sketches.

1 TONE THE CANVAS AND BLOCK IN THE BACKGROUND FOLIAGE

Use a neutral color to cover the white canvas; this makes it easier to see values correctly. A mixture of Ultramarine Blue and Indian Red is a good choice. Apply the paint with a no. 8 flat and a lot of paint thinner. If it gets too slippery, wipe down the canvas to get rid of any excess thinner. With a no. 6 or 8 flat, scrub in the large planes or areas of color. Do this very loosely. Use Ultramarine Blue and Yellow Ochre to block in the trees and add Alizarin Crimson to that mixture for the shrubs and bushes. Use Cadmium Yellow Light and Ultramarine Blue for the foreground. Very little (if any) Titanium White should be used. The goal here is to get a loose feel for the large areas of color so you can be more careful with the buildings. The contrast of loose and tight is important.

2 BLOCK IN THE BUILDINGS AND LARGE TREES

Carefully block in the buildings with a no. 2 flat. Use Ultramarine Blue and Indian Red. Keep it simple. Any excess detail at this point will only be covered up with paint.

Begin blocking in large areas of the trees with thicker paint, using a no. 6 filbert. It's important to keep the painting loose in these early stages.

3 BEGIN BLOCKING IN COLOR

Start blocking in large areas of color with thicker paint. Paint the buildings with a no. 4 filbert. Use a mixture of Titanium White and Yellow Ochre for the house. Mix a warm gray for the farm buildings using Cadmium Orange Hue and Titanium White. Gradually add Ultramarine Blue until the mixture turns to the warm gray that best represents the light on the barns. Keep in mind which direction the light is coming from and keep the light areas thicker than the dark areas. Continue blocking in color for all the large shapes.

For additional demos, bios, art and more, visit artistsnetwork.com/oil-painting-with-the-masters.

115

4 BREAK UP THE COLOR

Once you have blocked in color for all the large shapes, you'll need to break up those large areas with subtle color changes while trying to keep the value the same. In the foreground grass, use a no. 4 or 6 filbert and mix a variety of colors into a yellow green. Look for different varieties of yellow and orange—even some red and violet—as long as the values are close. You'll need to do the same thing with the flat walls of the buildings—they need very subtle color changes to make them look atmospheric.

5 BUILD UP THE TREES AND FOLIAGE

As you break up the color in the trees, follow their form using short and long brushstrokes. Look for a variety of colors and sky holes in the trees. The sky holes create shape and space in and around the trees. Make sure you soften the edges of the sky holes with a clean brush so they don't jump out of the picture. Use a no. 8 sable round on the tree trunks and branches to capture their long flowing shape. For the broken color in the trees, use a subtle change in the mixtures.

For the large green trees on the left, mix Ultramarine Blue and Cadmium Yellow Light with a little bit of Cadmium Red Light. To break up the color, mix the same value but add more blue or yellow or red. Also add a little orange or Alizarin Crimson to give the trees a color change but not a value change. All of the trees should have some kind of blue-yellow with a little red. The trees that look yellow-green will have more yellow than blue and red. The trees that look reddish-green will have more red than blue and yellow.

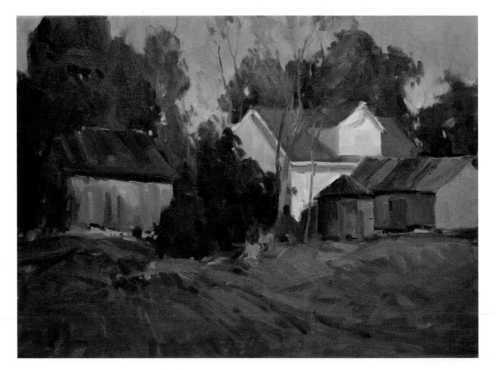

6 CONTINUE BUILDING BRUSHSTROKES

Continue building brushstrokes. Follow the form of the trees and grass. The brushstrokes in the grass should follow each undulating hill. Use no. 4 filberts with blues and yellows mixed with grays (Ultramarine Blue and orange) and violets (Ultramarine Blue and Alizarin Crimson). Keep your brushstrokes on the buildings vertical to enhance their shapes. Use nos. 2 and 4 filberts and keep your brush loaded with paint. Break up the color of the buildings with subtle color changes of blues and reds. Wipe some of the paint off the brushes as you do this, so that you just effect the color of the barns, but you don't actually change the color.

7 PAINT THE WINDOWS AND DOORS

Now that all the large shapes have the right value and broken color, use the smaller brushes, a no. 2 flat and a no. 8 sable to paint the windows and small darks and lights in the buildings and trees. Keep this to a minimum though—the broken color you added in step 4 created a sense of detail already. Too much more detail will ruin the painting. For the windows and doors use Ultramarine Blue and Cadmium Orange Hue to create a dark that has color in it but doesn't look like a black hole.

8 BUILD UP THE FOREGROUND

With the trees and the buildings finished, turn your focus to the foreground grass and sloping hill. Look for more color changes in the grass and for some lighter areas and highlights like the pale yellow grass along the fence. Use Yellow Ochre, Titanium White and a small amount of Alizarin Crimson with nos. 2 and 4 filberts to build up the grass. The grass is tall, so pull the strokes upward and let them blend into the darker green grass. Paint the fence posts with a no. 8 sable round and Titanium White and Yellow Ochre to keep the temperature warm.

9 PAINT THE SHEEP

The sheep are not part of the reference photo, but they are a good fit for adding interest to the painting. Since the sheep are a light value against the darker value of the grass, block them in with a warm muted color. Use a no. 2 filbert with Yellow Ochre, Titanium White and a touch of Ultramarine Blue, being careful to just block in a silhouette of the sheep and arrange them so they keep the composition balanced.

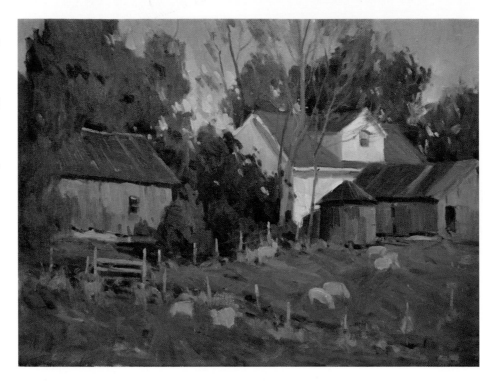

10 BUILD VALUES IN THE SHEEP

Use a no. 2 acrylic round to simplify the shape of the sheep with the three values (dark, light and middle value) that you started with. Detail is unnecessary at this stage because the sheep are not the focal point in the painting, and so, should be treated with just strokes of value. Try and stay away from outlines. There are no outlines in nature, just shapes.

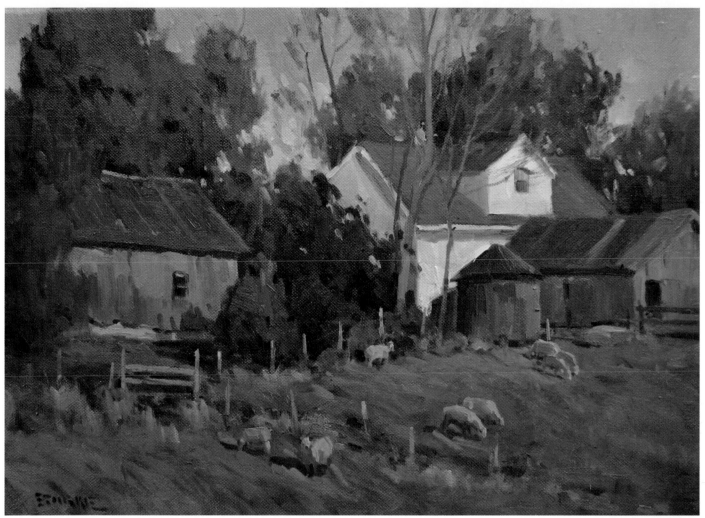

Morning in October
Phil Starke
Oil on canvas, 12" × 16" (30cm × 41cm)

11 ADJUST EDGES TO FINISH

Look at the edges of the trees, buildings, grass, etc. Decide whether the edges need to be softer or harder. Use a clean brush to pull out the softer edges and paint into an area to create a hard edge.

To learn more about Phil Starke, his art, classes and more, visit:

ఌ PHILSTARKE.COM

ఌ ARTISTSNETWORK.COM/OIL-PAINTING-WITH-THE-MASTERS

MOVEMENT
with George Gallo

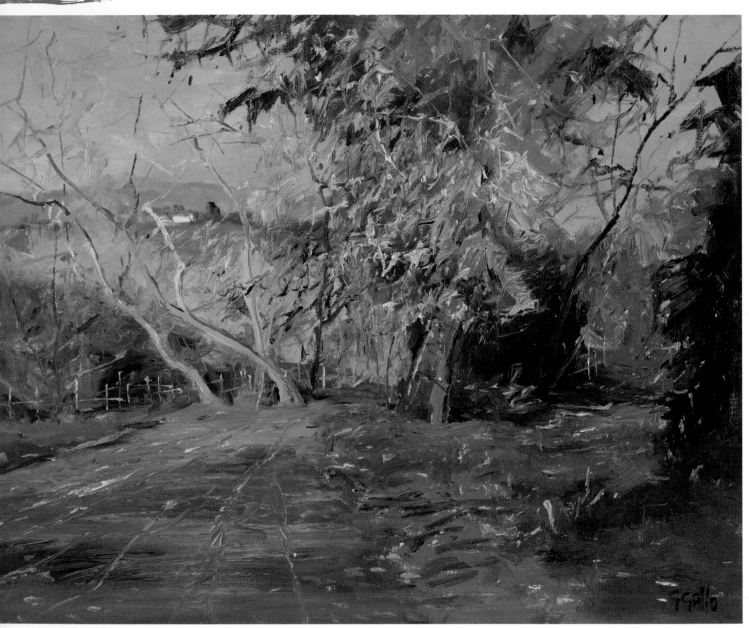

Woods at Sunset
George Gallo
Oil on canvas,
22" × 28"
(56cm × 71cm)

"**IF YOU HEAR A VOICE INSIDE YOU**
*say, 'You cannot paint,' then by all means
paint, and that voice will be silenced.*"

—VINCENT VAN GOGH

ABOUT **GEORGE GALLO**

In addition to being one of today's great master painters, George Gallo is also a screenwriter, director and producer. He has enjoyed painting since his childhood. While in junior high, he discovered a building next to his school where paintings by both old and modern masters were made into prints for the mass market. "I can't tell you the impact this had on me. Two very kind employees let me spend countless afternoons there studying paintings. It was there, seeing those oil paintings up close, that I developed a love for the texture of paint."

George studied art at Manhattanville College outside of New York City but only attended two semesters. "There were several good teachers there, but the school had a tendency to lean towards modernism, which I wasn't very interested in. I was hungry to focus on landscape painting, which led to me leaving college early."

George began making trips into the city on a regular basis. He wandered into an art gallery one afternoon where a salesman introduced him to the work of the Pennsylvania Impressionists. "Edward Redfield's large, dynamic snow scenes filled with huge smacks of paint were the most amazing canvases I had ever seen."

Around that same time, he met landscape painter, George Cherepov. "He and I became fast friends. We would visit places armed with our sketch boxes. Cherepov would scold me, saying that my clouds looked like flying rocks—that everything reflected the sky, and that I just wasn't looking hard enough."

Another of George's mentors was Aureillo Yammerino. "He was a modernist but was also classically trained. He kept talking about design and how it was the most important thing in any work of art. I would nod a lot, but had no idea what he was talking about. He kept drilling into my head that the placement of shapes was the most important thing. He was completely correct."

After moving to Los Angeles to pursue a screen writing and directing career, George shied away from painting for nearly eight years. He wrote and directed *Local Color,* a film about an aspiring young artist who befriends an elderly Russian master. It wasn't until after the success of his screenplay, *Midnight Run,* that he picked up the brushes and paint again.

Fate stepped in when actor John Ashton told George that his neighbor was an artist. "He's supposed to be pretty

George Gallo

good. His name is Richard Schmid," said Ashton. After Gallo picked his jaw up from the ground, he asked if Ashton would introduce him to Schmid. "Richard and I became friends via telephone and letters. I sent him several transparencies of my work, and he sent me back beautifully detailed critiques on how to improve my color, value, edges and design. It had a major impact on my work and got me thinking in entirely new directions."

George knows of no better way to cleanse the soul than painting plein air landscapes. "Nature is what it is. I am in awe of the sheer unyielding natural beauty of what lies around us. It is impossible for me to stand before a mountain and not be completely aware of my mortality. It will be here long after I am gone, but at the moment in time that we meet, I feel the need to not only recognize its beauty, but let others know that I tipped my hat to its glory."

George is represented by American Legacy Fine Arts, Pasadena, California; Bucks County Gallery of Fine Art, New Hope, Pennsylvania; George Stern Fine Arts, West Hollywood, California; Lois Wagner Fine Arts, New York City; Newman Galleries, Philadelphia; The Bluebird Gallery, Laguna Beach, California; Paderewski Gallery, Beaver Creek, Colorado, and Seaside Gallery, Pismo Beach, California.

For additional demos, bios, art and more, visit artistsnetwork.com/oil-painting-with-the-masters.

121

ON **MOVEMENT**

Whenever you see something that moves you to paint, you should feel excitement building up within you. That energy and enthusiasm should find its way into the entire practice of creating your painting—and it should be the basis of the painting itself.

One sure way of creating excitement in a painting is to create a strong sense of movement in the piece. This will help lead the viewer's eye through the composition. Eye movement can be achieved in a variety of ways.

Connecting Shapes

Connecting the darks in a subject is one way to create a sense of movement. Connecting the lights is another. For example, the long shadows of trees in the evening can stretch across your canvas and be used as a device to connect the other shapes in the composition.

Juxtaposing Color

Eye movement can be created by the juxtaposition of colors, generally by using the interaction of your three secondary colors—green, purple and orange. Smart use of these colors coupled with a dynamic design is a surefire way to achieve movement in a painting.

Color Vibrations

Look for color vibrations inside of objects. A white house hit with direct sunlight will be pretty much any color but white. It will have both the warm colors of the sun and the cool colors of the sky mixed into it. Finding those similar hues in the rest of the painting is another great way to get the viewer's eye to move.

Line

Line is also a very important tool to get the eye to move across a painting. The shape of a road or path or a river or a stream are wonderful compositional devices to pull in the viewer's eye and get it moving throughout a painting.

Texture

The texture of oil paint itself can also be used as a fun way to make the viewer's eye move through a painting. Fluid strokes, rapid strokes and even repetitious strokes add variety and excitement, as well as creating a sense of direction inside of a composition.

A Circle Pattern

A good painting has to have a sound design. This is achieved by taking what you see and putting it down in an arrangement that is pleasing, dynamic and clear. The shapes have to complement one another and connect in a way that causes the eye to take something in (the focal point), and then begin to move all over the canvas, finding new wonders and pleasures for the senses without competing with the main subject. Older painters would refer to this as a circle pattern.

The idea of a circle pattern can best be described like this: Picture a group of trees that rise up and connect to the sky. There the trees meet with clouds that have shapes that lead the eye across the canvas over to another tree line. That tree line leads the eye by following the trunks down to the grass where a fallen tree lies. The fallen tree leads the eye across the grass and into the river. The fallen tree connects to the opposite shoreline where it meets with a shadow that leads the eye back to the original group of trees.

When to Stop

A question George often gets asked is how he knows when a painting is finished. "The answer is that I'm not completely sure. One has to resist the impulse to keep adding 'just one more thing to make it perfect.' There is an old expression that it takes two people to paint a painting—one person to paint it and another person to knock him out before he ruins it. An artist has to be both of those people. When I have said what I set out to say, I force myself to quit."

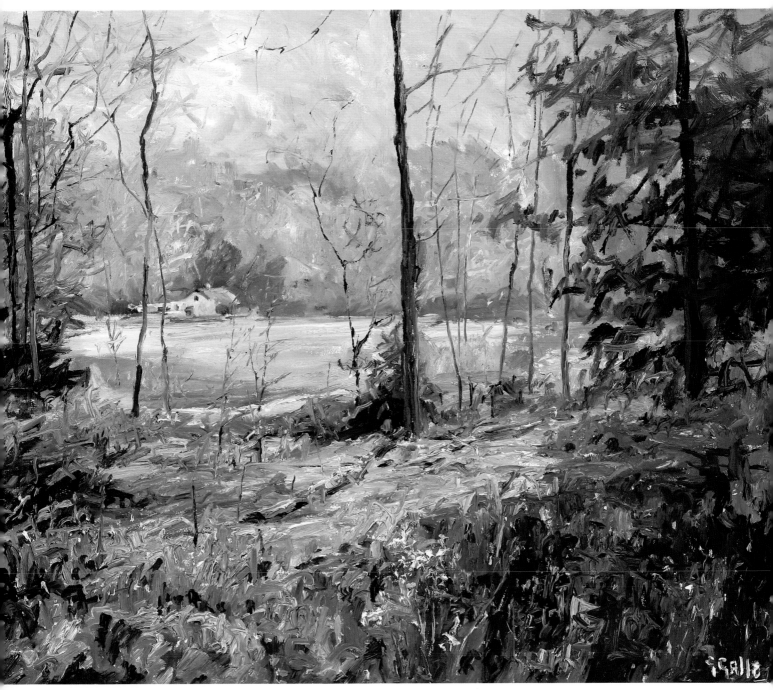

Connecting Elements Create Movement

Here the trees act as a connecting element and lead the eye up and down. The shape of the foreground leads the eye across and back up to the right, creating movement in a circle pattern.

Springtime
George Gallo
Oil on canvas, 30" × 36" (76cm × 91cm)

For additional demos, bios, art and more, visit artistsnetwork.com/oil-painting-with-the-masters.

123

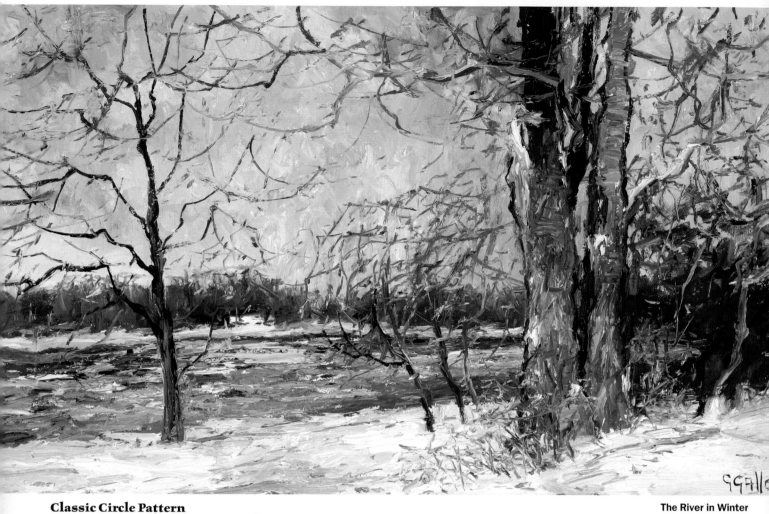

Classic Circle Pattern

The eye goes to the main group of trees on the right, then follows the main branch over to the secondary group of trees. The eye is led down the secondary group over to the foreground shadows and back over to the main group of trees.

The River in Winter
George Gallo
Oil on canvas, 24" × 42" (61cm × 107cm)

Color and Movement

Color also creates movement. Here, the eye goes to the splash of yellow, then follows the white birch trees up and over to the dark underside of the bridge. The figures, which are the main focal point, are dark against light.

Under the Bridge
George Gallo
Oil on canvas, 24" × 36" (61cm × 91cm)

Use Directional Lines to Create Movement
Lines create movement. Everything subtly points to the figure.

Copake, New York
George Gallo
Oil on canvas, 24" × 36" (61cm × 91cm)

Convey Movement with Brushstrokes
Brushstrokes can create great movement. Here, a series of vertical, horizontal and diagonal strokes create the feeling of wind and energy.

Peter Strauss Ranch, Malibu (Autumn)
George Gallo
Oil on canvas, 30" × 48" (76cm × 122cm)

For additional demos, bios, art and more, visit **artistsnetwork.com/oil-painting-with-the-masters.**

Paint a Landscape
WITH A SENSE OF MOVEMENT

Follow the steps as George Gallo shows how to paint a landscape with a sense of movement in the style of the Pennsylvania Impressionists. Like the French Impressionists, the Pennsylvania Impressionists painted en plein air and focused on capturing the qualities of color and light.

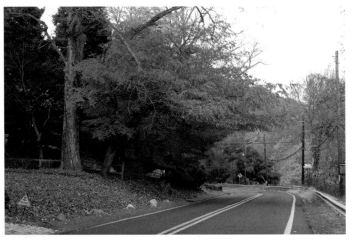

Reference Photo
George photographed this scene for use in this step-by-step demo.
He usually creates his paintings outdoors, from life.

Materials

SURFACE
stretched oil-primed linen

BRUSHES
no. 6 filbert
nos. 0 and 2 riggers
¼" (6mm) and ⅜" (10mm) daggers

PIGMENTS
Alizarin Crimson, Cadmium Lemon Yellow, Cadmium Orange, Cadmium Red Deep, Cadmium Yellow Deep, Ivory Black, Phthalo Blue, Titanium White, Ultramarine Blue

OTHER
odorless mineral spirits
palette knife

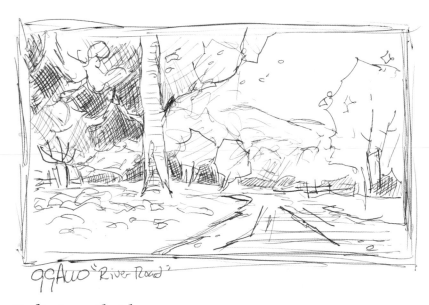

Preliminary Sketch
The best way to create a good composition is by working it out on paper first.
Arrange the big shapes, and forget about the details.

Pennsylvania Impressionists

One of the best known colonies of the Pennsylvania Impressionists was located on the banks of the Delaware River in Bucks County, Pennsylvania. Many distinctive artists emerged from this Movement, including Daniel Garber, Edward Redfield, John Fulton Folinsbee, George Sotter and William Lathrop.

1 BLOCK IN THE FOCAL POINT

If you create a well-composed painting, then your painting is nearly half finished. No matter how beautiful the technique, the colors, or the drawing, it is all for nothing if it hangs on a poorly constructed composition. Here the tree that is left of center is the main focal point. Getting the placement of the tree correct is the most important element of this painting. Start by brushing in the composition using a ¼" (6mm) dagger and a mixture of Ultramarine Blue and Alizarin Crimson. (Start with cool colors for paintings that will eventually have lots of warm light.)

2 FINISH LAYING IN THE COMPOSITION

Widen the road. Keep it dramatic. Suggest the branches of the main tree and the tree line to the right. Indicate the lines of the distant hillside. Use a ¼" (6mm) dagger and a mix of Ultramarine Blue and Alizarin Crimson diluted with odorless mineral spirits for this. See everything as part of one big design and not separate elements. Are they helping the main focal point or distracting from it? Simplify it or eliminate what is not needed.

3 PAINT THE SKY

Remember that in landscape painting the sky is always the father of the painting. Some versions of it will be in every other color—this is how to achieve harmony. Paint the sky with a no. 6 filbert and mixtures of Titanium White, Ultramarine Blue and Alizarin Crimson along with touches of Cadmium Red Deep and Cadmium Orange. You can even include a few flecks of Cadmium Yellow Deep in the warmer areas. The combination of Ultramarine Blue, Alizarin Crimson and Cadmium Orange create the more neutral areas of the sky.

For additional demos, bios, art and more, visit **artistsnetwork.com/oil-painting-with-the-masters**.

127

4 PAINT THE DISTANT HILLSIDE

Paint the distant hillside with a mixture of Phthalo Blue and Cadmium Red Deep using a ¼" (6mm) dagger. The blue/red combination creates a neutralized green and causes it to lay back, feeling distant. Add a bit of Titanium White to add to the feeling of distance. Remember that the air on a day like this is thick with moisture. Therefore, the previously mixed sky color should also be used to highlight the distant hillside.

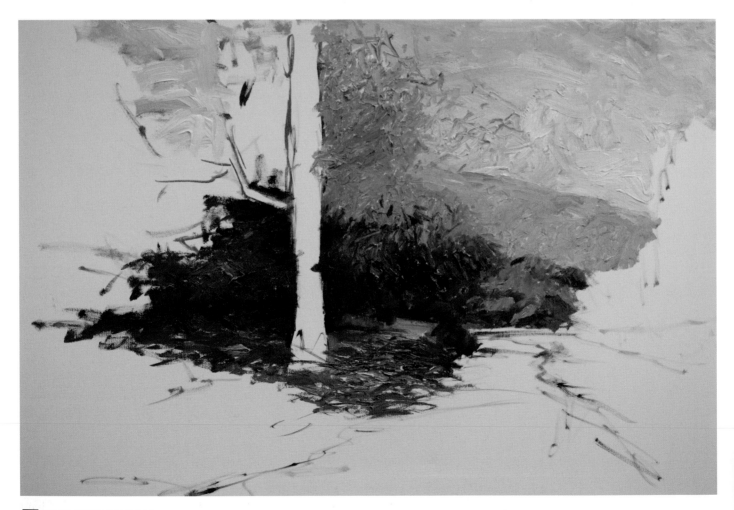

5 PAINT THE LEAVES

Paint in the warm tones of the autumn leaves. Use a ¼" (6mm) dagger and lots of paint, working various combinations of Cadmium Red Deep, Cadmium Orange and Cadmium Yellow Deep. Use occasional bits of your sky color here to create harmony. Work in your dark masses behind the main tree using Ultramarine Blue and Alizarin Crimson. Lighter areas should be done with Ultramarine Blue and Cadmium Red Deep. This is all harmonious because these are variations of the same color combinations that were used for the sky. This isn't a trick. This is what happens in nature.

6 ADD TEXTURE AND HIGHLIGHTS

Use a ¼" (6mm) dagger to suggest textures with the paint. Add variety by using different brushstrokes to suggest shifts in texture, value and color temperature. Use heavy paint application and descriptive strokes. Staccato strokes should be used to depict the leaves, and long strokes to describe the bark of the tree. Use a ⅜" (10mm) dagger with Cadmium Lemon Yellow and bits of the sky color to suggest highlights on the leaves.

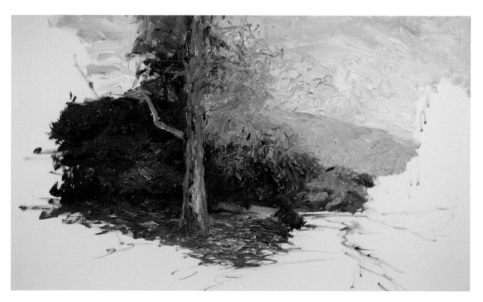

7 BUILD UP THE FOCAL POINT

Lay in more of the background and build up the focal point, which is the tree. The tree should be a cool gray leaning towards purple. Mix Alizarin Crimson, Ultramarine Blue, Cadmium Red Deep (for more neutral areas) and Titanium White and apply with a ¼" (6mm) dagger. Add in a few bits of the sky color here and there with the edge of a palette knife to hold it all together.

8 CREATE MORE TEXTURE

Use the texture of the paint to suggest the direction of things. Paint the bark using vertical strokes with a ¼" (6mm) dagger and a mix of Ultramarine Blue and Titanium White. Paint the leaves using horizontal strokes with a ⅜" (10mm) dagger and Cadmium Orange and Cadmium Red Deep. This will help create excitement and variety in the painting.

For additional demos, bios, art and more, visit **artistsnetwork.com/oil-painting-with-the-masters**.

129

9 FINISH THE BACKGROUND

Continue finishing up the background, switching between ¼" (6mm) and ⅜" (10mm) daggers using combinations of purple and green. To get the purple tones, use Ultramarine Blue and Alizarin Crimson. To get the darker green tones, use Phthalo Blue, Cadmium Orange and just a touch of Cadmium Red Deep. Suggest green pines in the background to echo the lighter greens of the distant hillside. Mix Phthalo Blue, Cadmium Yellow Deep and Cadmium Red Deep to neutralize the darker greens.

10 PAINT THE ROAD

Paint the road a cool neutral with lots of purple tones using a mix of Ultramarine Blue, Alizarin Crimson and a touch of Titanium White. Keep it loose and suggestive. Don't add so much to it that it begins to compete with the main focal point. Add a few lines in the road with nos. 0 and 2 riggers and a mix of Ultramarine Blue and Alizarin Crimson to suggest the feeling that the road has been traveled. This is also a great device to help lead the viewer's eye into the painting.

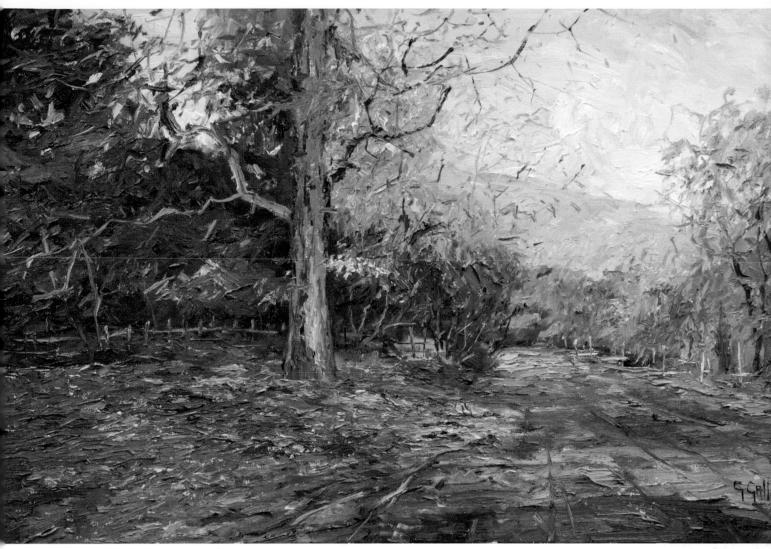

Autumn on River Road
George Gallo
Oil on linen, 24" × 36" (61cm × 91cm)

11 ADD FINISHING TOUCHES

Look for places where you can create harmony. Add warm notes to the cool road with a no. 0 rigger and Cadmium Lemon Yellow and Cadmium Orange. Suggest scattered leaves here and there. Add a few branches to the tree to pull the composition together. Use a ¼" (6mm) dagger to sharpen various edges throughout the piece. Paint in the fence with a no. 0 rigger and Titanium White, Ultramarine Blue and Alizarin Crimson.

To learn more about George Gallo, his art, his film, *Local Color,* and more, visit:

~ GGALLO.COM

~ ARTISTSNETWORK.COM/OIL-PAINTING-WITH-THE-MASTERS

More of
TODAY'S
MASTERS

Pianist
Glenn Harrington
Oil on linen, 18" × 24" (46cm × 61cm)

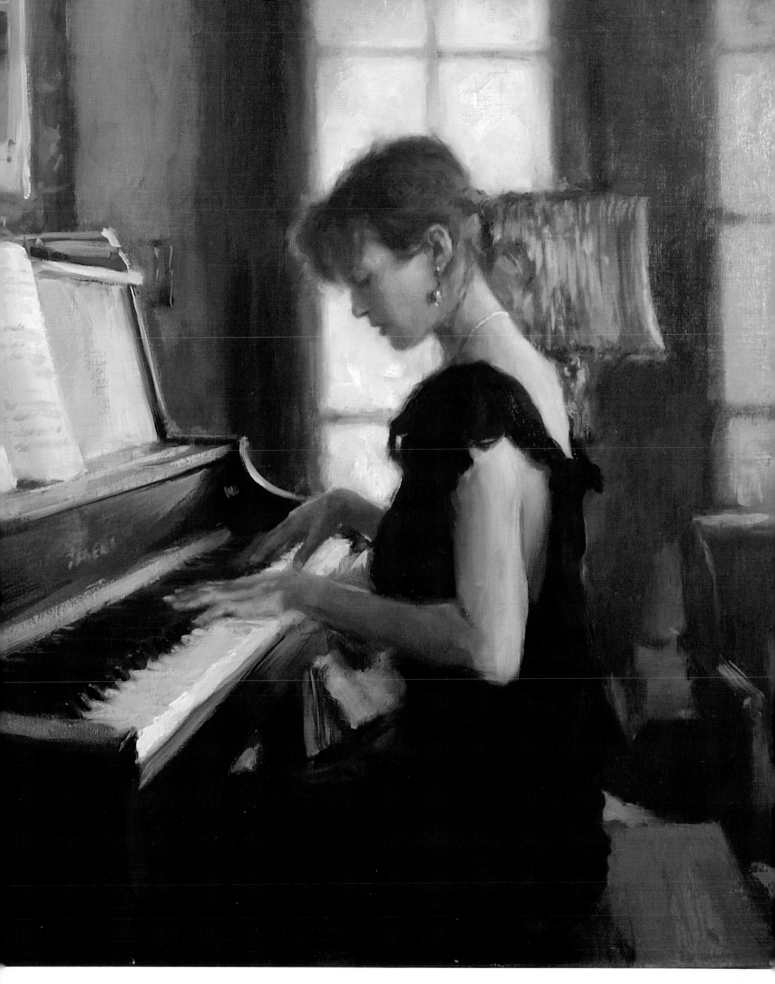

For additional demos, bios, art and more, visit artistsnetwork.com/oil-painting-with-the-masters.

133

ALBERT **HANDELL**

Albert Handell is a consistent award-winning artist with a national reputation for both oil and pastel painting. His works are in numerous private and public collections as well as in the permanent collections of many museums including: the Brooklyn Museum of Art, Brooklyn, New York; the State Capitol Collection of New Mexico, Santa Fe, New Mexico; the Butler Institute of American Art, Youngstown, Ohio; and the Albrecht-Kemper Museum, Saint Joseph, Missouri.

Albert lived in Europe from 1961 to 1965, setting up a studio in Paris. He often painted inside the Louvre, copying the old masters. He is the author of five art instruction books on oils and pastels and has been a featured artist in numerous art magazines.

The Pastel Society of America selected him to be included in the Pastel Hall of Fame in 1987. And in 2007, the Butler Museum of American Art honored him with a retrospective of his pastels.

Albert shares his knowledge and experience through his plein air painting workshops, including his advanced program, the Come Paint Along Mentoring Program, where aspiring artists join him at his favorite painting locations.

Albert Handell

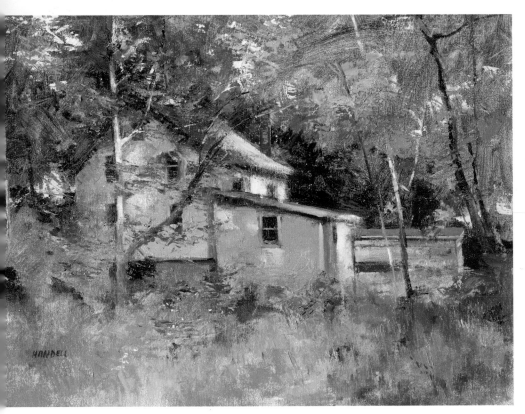

Since 1961, he has had more than sixty one-man shows throughout the United States. For the past twenty-five years, he has had his annual one-man show at the Ventana Fine Art Gallery in Santa Fe.

Albert lives and paints in New Mexico. Visit **alberthandell.com** for more information.

Mid Summer
Albert Handell
Oil on canvas, 18" × 24" (46cm × 61cm)
Courtesy of Andrew Johnson, Ventana Fine Art
Gallery, Santa Fe, New Mexico

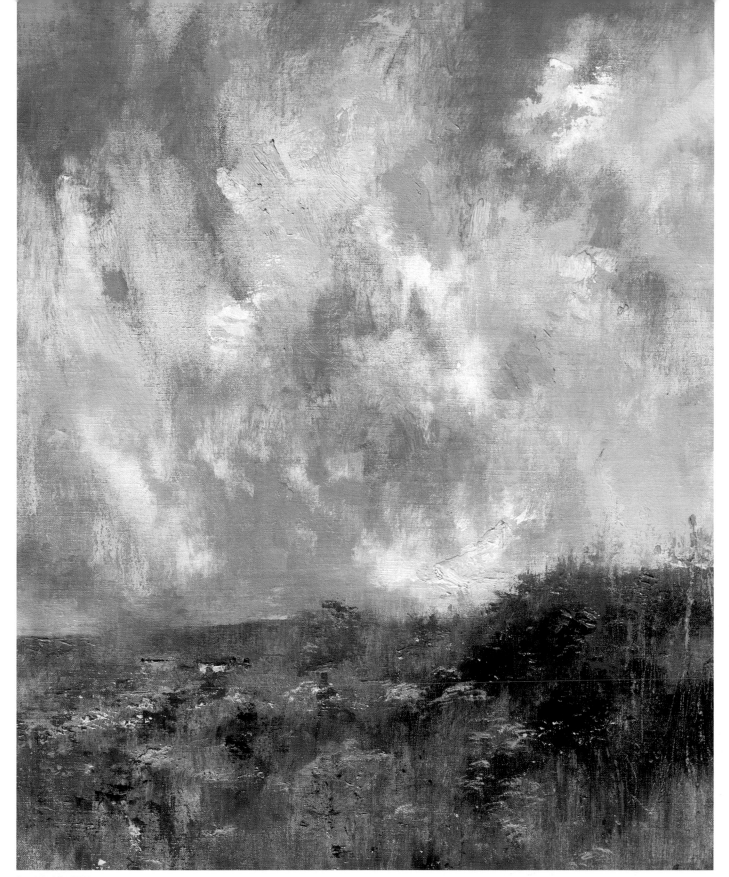

Summer Swirl Taos
Albert Handell
Oil on canvas, 24" × 18" (61cm × 46cm)
Courtesy of Andrew Johnson, Ventana Fine Art
Gallery, Santa Fe, New Mexico

For additional demos, bios, art and more, visit artistsnetwork.com/oil-painting-with-the-masters.

135

BRENT JENSEN

As a traditional Impressionist-style oil painter, Brent Jensen strives to create museum-quality art. His painting technique uses a loose approach, limited palette and objective perspective so that any two viewers are able to interpret one of his paintings differently. He believes a properly selected composition that is well executed brings a lifetime of enjoyment to a collector.

After receiving his B.A. in art from the University of Utah, Brent owned a successful architectural illustration company for fifteen years. It was during that time he began plein air oil painting. Gradually his oil painting skills progressed, and he eventually devoted himself towards a full-time career as a fine artist.

He lives in Northern California, which affords him many plein air painting opportunities in the wine country and along the Pacific coastline.

Brent has had feature articles in *Southwest Art*, *Art of the West* and *American Art Collector* magazines. He is represented by Waterhouse Gallery, Santa Barbara, California; Tirage Gallery, Pasadena, California; New Masters Gallery, Carmel, California; and Greenhouse Gallery, San Antonio, Texas.

Brent Jensen

As a lifelong student of the arts, Brent often participates in workshops with renowned artists such as Kevin Macpherson and his mentor C.W. Mundy. He also conducts workshops of his own, travels to art clubs for demonstrations and has judged multiple art shows.

Visit **jensenstudio.com** for more information.

Sheep Grazing in Petaluma
Brent Jensen
Oil on canvas, 16" × 20" (41cm × 51cm)

Wine Shipment
Brent Jensen
Oil on canvas, 20" × 16" (51cm × 41cm)

For additional demos, bios, art and more, visit **artistsnetwork.com/oil-painting-with-the-masters**.

137

C.W. MUNDY

C.W. Mundy is an American Impressionist artist who was born and raised in Indianapolis, Indiana. After graduating with a fine-art degree from Ball State University in Indiana in 1969, he made his home in California, painting, playing music and working on his Masters of Fine Art at Long Beach State University.

In 1978, he returned to Indiana where he worked as a sports illustrator for more than a decade. In the early 1990s, he took on the challenge of painting en plein air and from life. This led him on a series of European plein air painting trips.

In 2003, C.W. was invited to become Master Signature Member in the national organization Oil Painters of America. In 2007, he achieved Master Status in the American Impressionist Society. He is also a Signature Member of the American Society of Marine Artists. He lectures and teaches workshops throughout the United States.

C.W. has been featured in *The Artist's Magazine, American Artist Workshop Magazine, Plein Air Magazine, American Artist, Southwest Art, American Art Collector, Art of the West* and *International Artist* magazines.

C.W. Mundy

He is represented by Gallery 1261, Denver, Colorado; Anne Irwin Fine Art Gallery, Atlanta, Georgia; InSight Gallery, Fredericksburg, Texas; Eckert & Ross Fine Art, Indianapolis; and Castle Gallery, Ft. Wayne, Indiana.

He also enjoys playing banjo with the bluegrass band the Disco Mountain Boys and recently recorded his debut album, *Road Trip*, produced by Moon Surf Records.

Visit **cwmundy.com** for more information.

Red Striped Umbrellas
C.W. Mundy
Oil on linen, 16" × 20" (41cm × 51cm)

Portrait of Anne
C.W. Mundy
Oil on linen, 36" × 24"
(91cm × 61cm)

For additional demos, bios, art and more, visit **artistsnetwork.com/oil-painting-with-the-masters**.

139

QUANG **HO**

Quang Ho was born in Hue, Vietnam, and immigrated to the United States with his family in 1975. At the age of 16, Quang held his first one-man show at Tomorrows Masters Gallery in Denver, Colorado. The exhibit was a smashing success for the high school sophomore.

In 1982, Quang's mother was killed in a tragic auto accident, leaving him responsible for raising five younger siblings. That same year, he was accepted into the Colorado Institute of Art on a National Scholastics Art Awards Scholarship. At CIA, he studied painting under Rene Bruhin, whom he credits with developing the foundation for his artistic understanding. He graduated in 1985 with the Best Portfolio Award for the graduating class and went on to pursue a successful career as a freelance illustrator.

Quang's first solo show at Saks Gallery in 1991 was a sell-out success. He went on to hold many successful solo shows in New Mexico, Texas and California.

His subject matter includes still lifes, landscapes, interiors, dancers and figures. His works have been featured in many

Quang Ho

national and international publications, and he has been honored with many prestigious awards. He is also a sought-after teacher and public speaker, and has also produced a number of teaching DVDs.

Quang is represented by Gallery 1261 in Denver, Colorado and Claggett Rey Gallery in Vail, Colorado.

Visit **quangho.com** for more information.

Summer Arrangement
Quang Ho
Oil on canvas, 36" × 36" (91cm × 91cm)

Mizuna
Quang Ho
Oil on canvas, 24" × 24" (61cm × 61cm)

TIBOR **NAGY**

Tibor Nagy was born and raised in the small town of Rimavská Sobota in Slovakia. From an early age, he found himself deeply connected with nature, and graphic expression in many forms felt very natural to him.

At the beginning of Tibor's artistic journey, realism combined with abstraction was the direction which prevailed in his style. Later, he started to incline more toward surrealism, combining techniques and experimentation while still searching for his own unique way of expression.

For many years, he has been trying to express his impressions from visual or spiritual experiences. His tireless effort, deeper understanding of his own self and willingness to share the moves of his soul brought him to new artistic perspectives.

Tibor's genuine aspiration for capturing the unique moments which nature offers during his walks and his deep reflections of landscape encounters, so clearly embedded in his mind, have led him toward a distinctive style.

Tibor Nagy

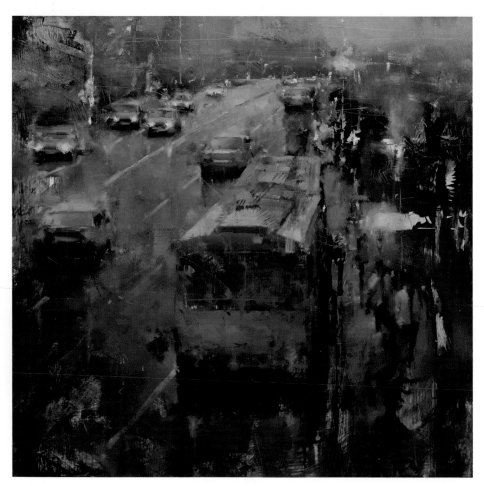

The power of light takes Tibor's brushwork and palette on a journey without real frontiers and transpose messages to lovers of his work His paintings are his true personal confessions.

Visit **nagytibor.com** for more information.

The Bus Stop
Tibor Nagy
Oil on wooden panel,
20" × 20" (51cm × 51cm)

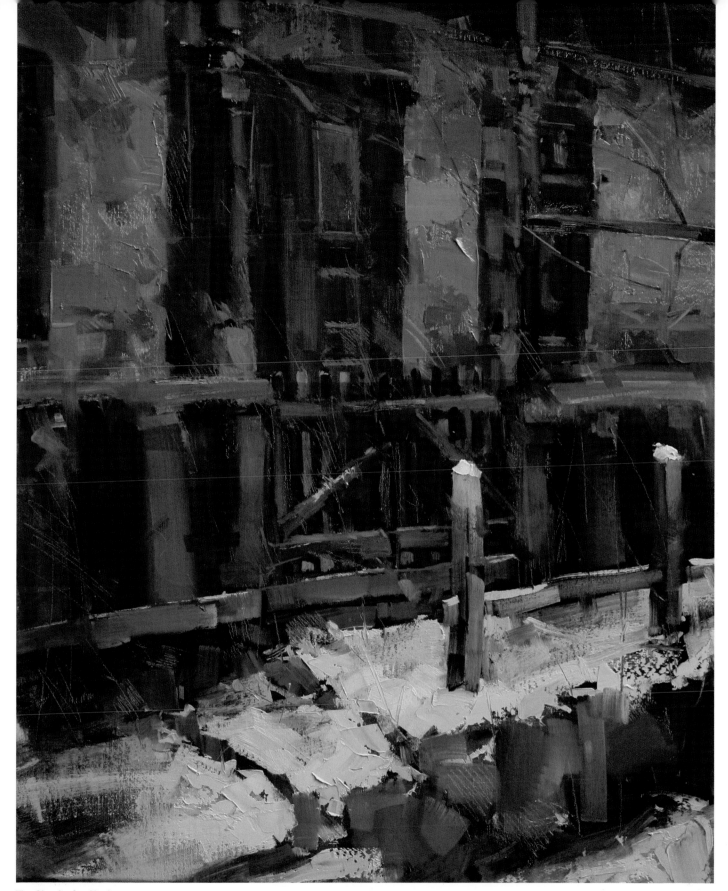

The Slumbering Yard
Tibor Nagy
Oil on linen, 18" × 14" (46cm × 36cm)

For additional demos, bios, art and more, visit artistsnetwork.com/oil-painting-with-the-masters.

143

GUIDO **FRICK**

Guido Frick was born in Konstanz, Germany. He worked for several years as a sports journalist covering events such as the Olympics, world championship boxing matches and soccer games.

After a serious car accident, he became handicapped for nearly two years. Since he had enjoyed drawing and watercolor painting from a very young age, he decided to sign up at the art academy in his hometown as soon as he was able to get around on crutches. He studied there for four years with Professor Karel Hodr, a well-known Impressionist. He would later go on to study under Russian Master Sergei Bongart.

When Guido discovered he could make a living from painting, he quit his reporting career and became a full-time painter. While traveling in the United States, he discovered a great love for the American West.

Guido is featured in the books *Art Journey America Landscapes: 89 Painters' Perspectives* by Kathy Kipp, and *Maler sehen den Bodensee: 200 Jahre Landschaftsmalerei aus privatem Besitz* by Carlo Karrenbauer. He has also been featured in *Southwest Art, American Artist Workshop* and *Western Art Collector* magazines.

Guido Frick

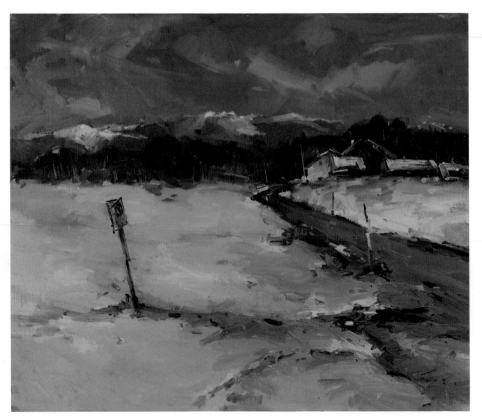

He has had numerous solo shows throughout the United States and Europe. He is represented by New Masters Gallery, Carmel, California; Sunset Art Gallery, Amarillo, Texas; Evergreen Fine Art Gallery, Evergreen, Colorado; Bebb Fine Art, Ludlow, England; and Galerie See Motiv, Konstanz, Germany.

Visit **guidofrick.com** for more information.

Way Below the Freezing Point
Guido Frick
Oil on canvas, 24" × 30" (61cm × 76cm)

Sunday Afternoon
Guido Frick
Oil on canvas, 36" × 36" (91cm × 91cm)

For additional demos, bios, art and more, visit **artistsnetwork.com/oil-painting-with-the-masters**.

145

JEREMY LIPKING

Jeremy Lipking was born in Santa Monica, California. The son of a professional illustrator, he was influenced by art throughout his childhood. Jeremy enjoyed watching his father paint in his studio and looked forward to their frequent trips to museums and art galleries.

After enrolling in the California Art Institute in 1996, he dedicated himself to long hours of drawing and painting.

Jeremy Lipking

His inspiration came from studying the works of the great Masters of the nineteenth century Realist Movement.

A defining moment for Jeremy was when he learned how to see like an artist. "Looking at a face and not seeing the eyes or the nose or the mouth, but seeing those shapes as simple light and dark patterns was a revelation to me."

He has been featured in *American Art Collector*, *American Artist*, *ArtNews* and *American Artist Workshop* magazines and is represented by Arcadia Gallery in New York City and American Legacy Fine Arts in Pasadena, California. He teaches his skills and techniques in art workshops throughout the United States.

Visit **jeremylipking.com** for more information.

Eden Rose
Jeremy Lipking
Oil on linen, 40" × 18" (102cm × 46cm)

Skylar in Blue
Jeremy Lipking
Oil on linen, 16" × 12" (41cm × 30cm)

For additional demos, bios, art and more, visit artistsnetwork.com/oil-painting-with-the-masters.

147

BARBARA **FLOWERS**

Barbara Flowers was raised in a small village near the Rhine Valley in Germany. Although her desire to create art began at a young age, her education was in foreign languages and she parlayed her multi-fluency into a thriving career as a foreign language correspondent.

Ultimately she made the decision to follow her passion by creating art that captures the same beauty that imbued her life abroad. She has never regretted making that decision.

Her paintings are recognized and collected internationally in private and corporate collections and have been featured in publications such as *American Art Collector* and *Southwest Art* magazines.

Barbara has had numerous group and solo exhibitions in Alabama, Florida, Georgia, Indiana, North Carolina and Virginia. She was the featured artist during the Huntsville, Alabama Museum of Art Gala in 2010.

In 2009, she received the Award of Excellence in the Oil Painters of America Eastern Regional. She received the President's Choice Award in the American Impressionist Society's 9th Annual National Exhibition in 2010.

Barbara Flowers

Barbara was a Finalist in the RayMar Art Third Annual Fine Art Competition. She is a Signature Member of the American Impressionist Society. She has studied painting with C.W. Mundy, Carolyn Anderson, Neil Patterson, Quang Ho and Sherrie McGraw. Barbara now resides in Florida.

Visit **barbaraflowersart.com** for more information.

Closed on Mondays
Barbara Flowers
Oil on canvas, 20" × 20" (51cm × 51cm)

Birch by the Lake
Barbara Flowers
Oil on canvas,
60" × 40"
(152cm × 102cm)

For additional demos, bios, art and more, visit **artistsnetwork.com/oil-painting-with-the-masters**.

149

LAWRENCE J. CHURSKI

Lawrence J. Churski began his study of drawing and painting in 1963 upon receiving a full scholarship to the Cooper School of Art. He continued his education at the Cleveland Institute of Art and later joined Artists Incorporated, an Akron, Ohio-based graphic design studio. He would eventually become owner and president of the company. During that time, he won numerous illustration and design awards including a National Addy.

Lawrence began plein air painting in 1986. He studied with nationally renowned artists such as Lowell Ellsworth Smith, Don Stone, Charles Reid, Robert Wade, Roberta Clark and Burton Silverman. Other important influences on Lawrence were Andrew Wyeth, John Singer Sargent, Edward Hopper and Richard Schmid.

In 1994, he bought The Mill at Yellow Creek, a restored Ohio grist mill constructed about 1830. Today it is the home to the Lawrence J. Churski studio and gallery, where he teaches and conducts workshops.

Lawrence J. Churski

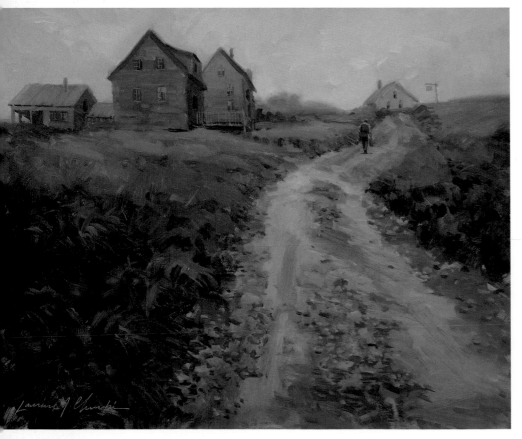

Lawrence has sold more than 5,000 works of art in his lifetime, and he has won numerous awards. His work is in the permanent collections of museums throughout the world and has appeared in *Plein Air Magazine, Southwest Art* and *American Art Collector* magazines.

Visit **lawrencechurski.com** for more information.

Monhegan Path
Lawrence J. Churski
Oil on masonite, 16" × 20" (41cm × 51cm)
In the collection of Judith B. Carducci

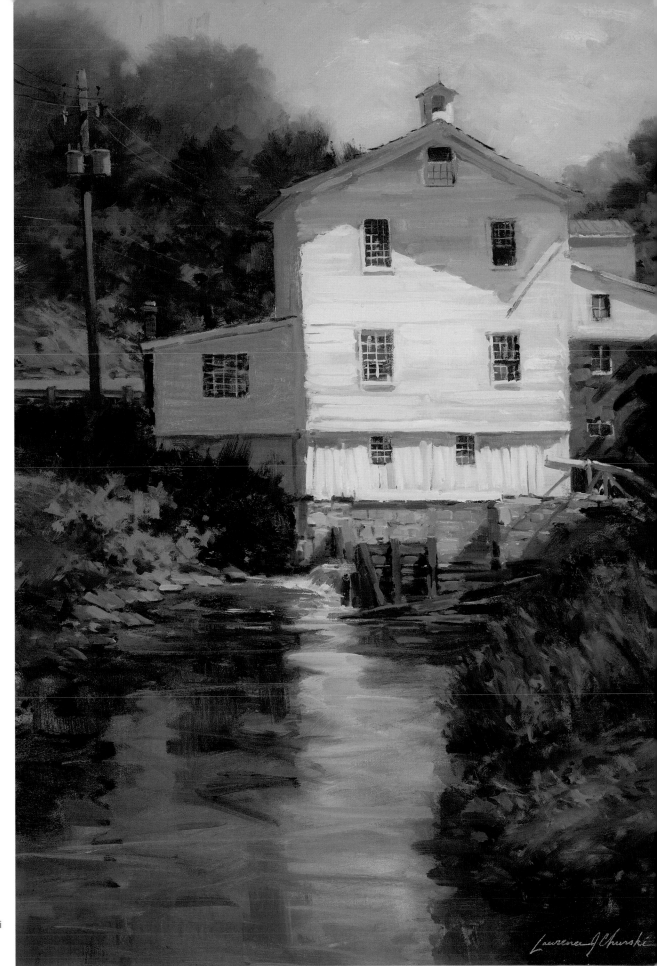

Wilson Mill
Lawrence J. Churski
Oil on canvas,
30" × 20"
(76cm × 51cm)

For additional demos, bios, art and more, visit **artistsnetwork.com/oil-painting-with-the-masters.**

GLENN **HARRINGTON**

Glenn Harrington was born in New York. He studied at Pratt Institute where he earned his B.F.A. but credits his father as his first and best teacher. His youthful employment as a sign painter and graphic designer were also beneficial to his later career as a painter.

His paintings are recognized and collected internationally and have been featured in *International Artist Magazine, American Arts Quarterly* and *American Art Collector* magazines, as well as on the covers of *American Artist* and *U.S. Art* magazines.

Glenn's paintings have been published on more than 600 book covers, including such classics as *Room with a View, Pride and Prejudice, Wuthering Heights, Women in Love, Jane Eyre* and *Dangerous Liaisons.*

His portrait of Maria Callas was used to promote the Tony Award-winning play *Master Class* and was reprinted on the cover of Terrance McNally's book by the same name. Glenn created fifty original oils for Disney's children's book *Tarzan* in 2000. Penguin Books recently republished Carl Sandburg's Pulitzer Prize winning book *Abe Lincoln Grows Up* with its cover painting by Glenn.

Glenn Harrington

In 2007, he received the Portrait Society of America's Draper Grand Prize. His recent portrait commissions include President George Bush, Dwight D. Eisenhower, Phil Mickelson and Fred Couples. In 2010 he won *American Art Collector* magazine's Editor's Choice Award in an exhibition organized by the International Guild of Realism.

Glenn has had numerous solo exhibitions in New York, Japan, London, South Carolina and Pennsylvania.

Visit **glennharrington.com** for more information.

Alex
Glenn Harrington
Oil on linen, 24" × 30" (61cm × 76cm)

Skater at Stover's Mill
Glenn Harrington
Oil on linen, 8" × 10" (20cm × 25cm)

For additional demos, bios, art and more, visit **artistsnetwork.com/oil-painting-with-the-masters**.

153

CONCLUSION:
LEARNING FROM THE MASTERS OF THE PAST

A wonderful opportunity exists to learn from the great masters of today. You can learn from these masters by studying their art instruction books, taking their workshops, watching online events and webinars or simply by inserting a DVD into your DVD player.

Unfortunately you can't take a workshop from Claude Monet or watch him paint on your TV. However, you can still learn so much from Monet and the other great masters of the past by studying their paintings in books or online, or by visiting art museums.

Viewing the paintings of past masters online is both easy and enjoyable. Still, nothing can take the place of studying the actual paintings in an art museum. Not only is there that ethereal feeling of being in a sacred place and the inspiration brought on by the sheer beauty of the artwork, but you can get close enough to the paintings to see the brushstrokes .

During a visit to the Butler Museum of American Art in Youngstown, Ohio, I was able to study one of the museum's greatest treasures, *Mrs. Knowles and Her Children* by John Singer Sargent. Sargent is my favorite old master. Seeing his exquisite brushstrokes on that painting sent goosebumps running up and down my arms.

One of my dreams is to visit every major art museum in the world. Unfortunately, life is short and a trip around the world is very costly, but thanks to the Internet, we really can visit every art museum in the world—right from the comfort of our homes.

Google's Art Project and artmatch4U.com provide visitors with a wealth of information to study and enjoy. Go to **artmatch4U.com/museums** for links to museums all over the world and Google's virtual tours of the major art museums.

Cindy Salaski

Spring Thaw, Evening Light
Albert Handell
Oil on canvas,
24" × 24"
(61cm × 61cm)

For additional demos, bios, art and more, visit **artistsnetwork.com/oil-painting-with-the-masters**.

155

RECOMMENDED **READING**

Sergei Bongart
MARY N. BALCOMB
Cody Publishing, 2002

Carlson's Guide to Landscape Painting
JOHN F. CARLSON
Dover Publications, 1973

Brushwork for the Oil Painter
EMILE A. GRUPPÉ
Watson-Guptill, 1983

Gruppé on Color
EMILE A. GRUPPÉ
Watson-Guptill, 1979

Gruppe on Painting
EMILE A. GRUPPE
Watson-Guptill, 1976

How to Draw Lifelike Portraits from Photographs
LEE HAMMOND
North Light Books, 1995

Intuitive Light
ALBERT HANDELL
Watson-Guptill, 2003

Hawthorne on Painting
MRS. CHARLES W. HAWTHORNE
Dover Publications, 1960

The Art Spirit
ROBERT HENRI
Basic Books, 2007

On Becoming a Painter
ROBERT A. JOHNSON
Sunflower Publishing, 2001

Color Harmony in Your Paintings
MARGARET KESSLER
North Light Books, 2004

The Natural Way to Draw
KIMON NICOLAÏDES
Hougton Mifflin Company, 1969

Fill Your Oil Paintings with Light and Color
KEVIN D. MACPHERSON
North Light Books, 2000

Landscape Painting Inside & Out
KEVIN D. MACPHERSON
North Light Books, 2009

Composition of Outdoor Painting
EDGAR PAYNE
DeRu Fine Arts, 2005

Oil Painting Pure and Simple
RON RANSON AND TREVOR CHAMBERLAIN
Blandford Press, 1986

Alla Prima: Everything I Know About Painting
RICHARD SCHMID
Stove Prairie Press, 2004

In Nature's Temple, The Life and Art of William Wendt
JANET BLAKE, JEAN STERN AND WILL SOUTH
The Irvine Museum - Laguna Art Museum, 2008

INDEX

For additional demos, bios, art and more, visit artistsnetwork.com/oil-painting-with-the-masters.

157

ABOUT THE **AUTHOR**

Cindy Salaski is the co-founder and CEO of ArtMatch4U. The vision of ArtMatch4U is to enable artists and art lovers quick and easy access to everything in the art world.

Much of Cindy's career has been in marketing and sales. From 1991 to 2006 she was a luxury home specialist with Realty Executives in Paradise Valley, Arizona. However, after studying with North Light author Eric Wiegardt at the Scottsdale Artists' School, she decided to focus on her first love—fine art.

Along with her duties at ArtMatch4U, Cindy paints in oils, watercolors and pastels. She has studied with Albert Handell, Barry John Raybould and Phil Starke. She was also in a mentorship with world-renowned plein air painter Kevin Macpherson from July 2010 to July 2011.

Cindy also enjoys writing. In 1984 she was named one of the top ten writers in the scripts category of the *Writer's Digest* magazine Writing Competition. In 1997, she won third place in Pure Fiction's Electronic Slush Pile. Cindy's article, "Mastering Brushstrokes with Albert Handell" was featured in the December/January 2013 issue of *International Artist* magazine.

Visit artmatch4u.com. for more information about ArtMatch4U.

Acknowledgments

I would like to thank the staff at North Light Books, especially Pamela Wissman, Jamie Markle, Richard Deliantoni, Kristin Conlin and Mona Clough. Thanks also goes out to Albert Handell for his inspiration, support and friendship, and to Kathleen Hanna, president and co-founder of ArtMatch4U, for her encouragement and never-ending supply of optimism. I would also like to thank Richard McKinley for his assistance. And last but not least, a big thank you to all the master artists who participated in this book.

Dedication

To my dad and mom, John and Martha Salaski, my two best friends.

METRIC CONVERSION CHART

TO CONVERT	TO	MULTIPLY BY
Inches	Centimeters	2.54
Centimeters	Inches	0.4
Feet	Centimeters	30.5
Centimeters	Feet	0.03
Yards	Meters	0.9
Meters	Yards	1.1

EDITED BY:
Kristy Conlin

DESIGNED BY:
Hannah Bailey

PRODUCTION COORDINATED BY:
Mark Griffin

Ohio Winter
Lawrence J. Churski
Oil on canvas, 16" × 20" (41cm × 51cm)
In the collection of Mr. and Mrs. Gregory Moore

Other fine North Light Books are available from your favorite bookstore, art supply store or online supplier. Visit our website at fwmedia.com.

18 17 16 15 14 5 4 3 2 1

DISTRIBUTED IN CANADA BY FRASER DIRECT
100 Armstrong Avenue
Georgetown, ON, Canada L7G 5S4
Tel: (905) 877-4411

DISTRIBUTED IN THE U.K. AND EUROPE
BY F&W MEDIA INTERNATIONAL LTD
Brunel House, Forde Close, Newton Abbot, TQ12 4PU, UK
Tel: (+44) 1626 323200, Fax: (+44) 1626 323319
Email: enquiries@fwmedia.com

DISTRIBUTED IN AUSTRALIA BY CAPRICORN LINK
P.O. Box 704, S. Windsor NSW, 2756 Australia
Tel: (02) 4560-1600; Fax: (02) 4577 5288

Email: books@capricornlink.com.au
ISBN 13: 978-1-4403-2993-7
Cover Image: *Summer Arrangement* by Quang Ho,
Oil on canvas, 36"× 36" (91cm × 91cm)

Photography Credits:
Kami Mendlik-Polzin, pg 9; Scott Burdic, pg 23; Garry McMichael, pg 35; Mary Wiltse, pg 47; Dale Axelrod, pg 59; Michael Clark, pg 71; Wanda Macpherson, pg 83; Virginia Johnson, pg 97; Phil Starke, pg 109; Tom Caltabiano, pg 121; Cindy Salaski, pg 134; Steven Morris, pg 136; Pamela Mougin, pg 138; Quang Ho, pg 140; Tibor Nagy, pg 142; Amy Jimmerson, pg 144; Jonathan Lipking, pg 146; Lisa Norman, pg 148; Dennis Roliff, pg 150

IDEAS. INSTRUCTION. INSPIRATION.

Receive **FREE** downloadable bonus materials when you sign up for our free newsletter at **artistsnetwork.com/Newsletter_Thanks.**

Find the latest issues of *The Artist's Magazine* on newsstands, or visit artistsnetwork.com.

These and other fine North Light products are available at your favorite art & craft retailer, bookstore or online supplier. Visit our websites at artistsnetwork.com and artistsnetwork.tv.

Follow North Light Books for the latest news, free wallpapers, free demos and chances to win FREE BOOKS!

GET YOUR **ART IN PRINT!**

Visit **artistsnetwork.com/competitions** for up-to-date information on North Light competitions.